ARTS & CRAFTS
NEEDLEPOINT

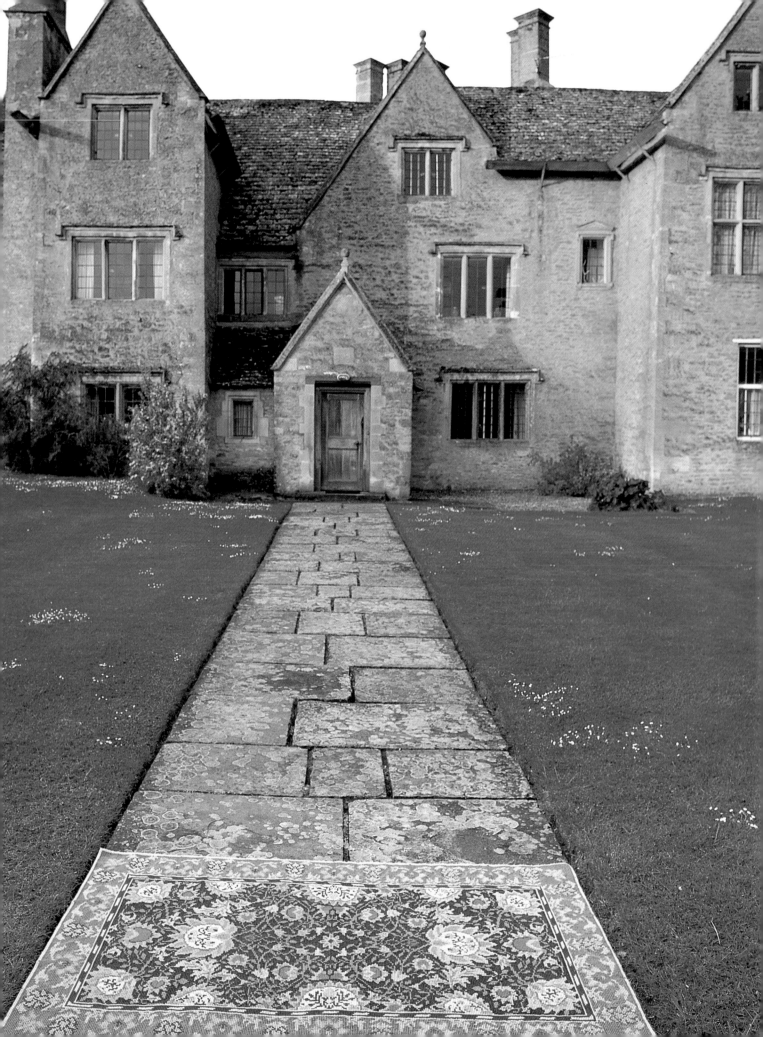

ARTS & CRAFTS NEEDLEPOINT

BETH RUSSELL

SPECIAL PHOTOGRAPHY BY JOHN GREENWOOD

 NATIONAL TRUST BOOKS

For Peter, Nick and Paul

First published in the United Kingdom in 1989
by Anaya Publishers Ltd

Paperback edition first published in 1996
by Collins and Brown Ltd

Revised and updated edition published in 2006
Reissued in paperback in 2009 by

National Trust Books
10 Southcombe Street
London W14 0RA

An imprint of Anova Books Company Ltd

ISBN: 9781905400805

A CIP catalogue record for this book is available from the British
Library.

15 14 13 12 11 10 09
10 9 8 7 6 5 4 3 2 1

Reproduction by Mission Productions Ltd, Hong Kong
Printed and bound by Craft Print International Ltd, Singapore

This book can be ordered direct from the publisher at the
website: www.anovabooks.com, or try your local bookshop.
Also available at National Trust shops.

CONTENTS

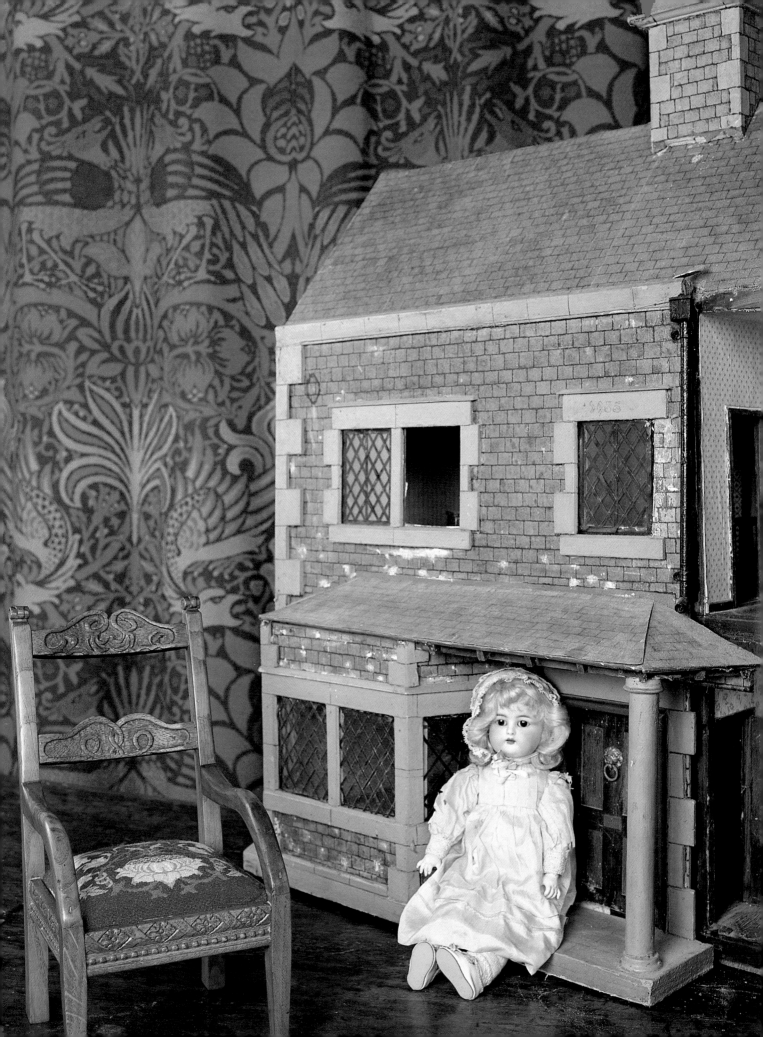

INTRODUCTION

My need to be creative has come, I think, from my family background. Three-quarters of the furniture in our house in Llansamlet, in South Wales, was made by my father. With the minimum of tools and space, he produced truly beautiful chairs, cabinets, beds and even wardrobes. I became accustomed to seeing him dovetailing joints, carving claw and ball feet, and French polishing. A great deal of this was done at home, and I was allowed to help with the sandpapering and polishing. There seemed nothing that my father could not teach himself to do well: he painted in oils and watercolours, tried beadwork, etched glass, made shoes, sewed and cooked.

Much of our linen had been embroidered by my mother's sister and all the curtains and covers were made at home. We slept on feather mattresses (the feathers from my mother's family farm), between crisply starched sheets, and there were carved swans' heads at the foot of my bed. Even my dolls had their own expanding table and carved chairs.

I was brought up to believe that the best things were those you made yourself. Bought objects were viewed most critically. Later on, my husband was a little startled when I suggested that whatever we needed we could make ourselves!

Above:
Swans' heads at the foot of my bed, carved by my father when I was a child. Teddy's sweater was my first attempt at knitting.

Left:
One of the doll's chairs made for me by my father, photographed here in Kelmscott Manor, William Morris's home in Gloucestershire from 1871 until his death in 1896. The needlepoint chair seat is a miniature version of *Lodden* (page 34). For details of how to adapt any of the designs in the book, see page 115.

My introduction to the style of decorative art, which has remained my favourite, took place on my seventh birthday. As a treat, I was allowed, on my own, to listen to a musical rehearsal in the Brangwyn Hall in Swansea. Magnificent panels, painted by Sir Frank Brangwyn (1867–1956) originally for the House of Lords, cover every wall. The immensely strong shapes and rich colours are awe-inspiring; there is not an inch of plain background. People, fruit and animals peep out from, or merge into, the dense, curving foliage. I do not think there is a straight line in one of the panels. It is this first deep impression of lines that sweep and move, and the generosity of design, that has stayed with me.

Frank Brangwyn had worked with William Morris' company. His trips to the East helped to develop his highly personal style, but the strong drawings, rich colours and romantic conception were shared by Morris and many of his contemporaries.

Much later, I continued to be drawn towards the work of this particular group of artists. When I married, *Bachelor's Button* was the first Morris fabric we chose to cover chairs and to make a large round tablecloth. Our second son was born into a room decorated with Morris' dramatic black and white *Indian* wallpaper and we had *Marigold* in the drawing room.

The years when the children were small were filled with curtain and clothes making. I joined a pottery class as we needed jugs and fruit dishes. Photography was an important hobby. We also developed an interest in children's illustrated books and began collecting Kate Greenaway, Arthur Rackham, Edmund Dulac and Walter Crane. My favourite book is *The Ancient Mariner*, illustrated by Willy Pogany. These artists belong to the same period as Brangwyn and Morris – the seeds sown so long before were beginning to sprout.

I started work at the Royal School of Needlework in London one autumn. At 25 Princes Gate, in what must be one of the loveliest buildings in London, I was surrounded by beautiful carving and mouldings, original Walter Crane paintings, hand-blocked wallpaper (also said to be by Crane) and a plethora of designs from the late 1800s and early 1900s. I became familiar with Appleton's yarn colours – there are over 400 and the ability to readily distinguish between them is a slowly learned art. Now I find that I think of colours only in terms of their Appleton names and numbers, even when buying clothes.

The very formal atmosphere when I started at the Royal School of Needlework was reminiscent of my days at college. Several people did not speak to me for weeks because (I later learned) I occasionally wore trousers. However, my memories are of a sundrenched room with high ceilings, tall French windows leading on to a terrace and a huge garden with a Japanese-looking tree in the centre. This delightful room was the shop, which some years later I was asked to run.

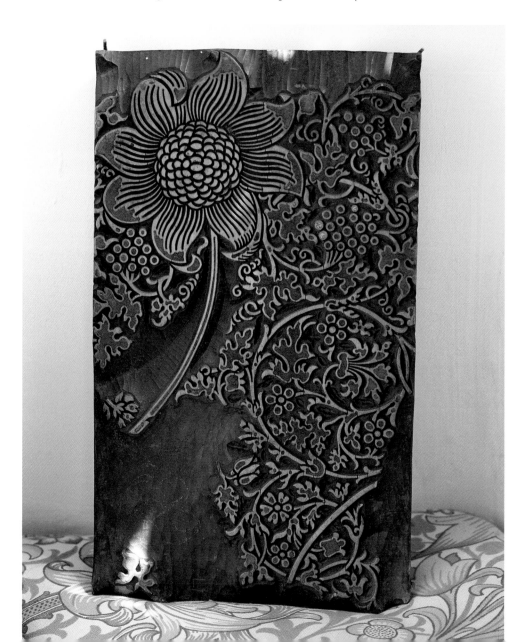

Right:
The original pear wood block used to print William Morris's *Kennet* fabric.

8

Right:
Jean Wells has adapted the designs from *Strawberry Thief* and *Wild Flowers* for Kelmscott church, where Morris is buried.

Given free rein in the shop, I bought threads and embroidery tools I had not previously known existed. I searched for interesting books to sell, and the shop became known as a treasure trove for embroiderers. Customers were pleased, money started coming in, and I was thrilled. Old designs were rediscovered and new ones created. *The Daily Telegraph* frequently told its readers about us. It was a very exciting period in my life.

However, success brought its own problems. As we expanded and began selling to other shops and outlets overseas, the business side became more complex. I was promoted to sales manager and, to allow more time for administration and to accommodate more people in the shop, I moved away from the public (and the sun) into the basement. I felt that the challenge and the fun had gone. After twelve years, I left. Sadly, 25 Princes Gate has since been sold and the shop is now no more.

Eager to start afresh and do my own designing, I happened to learn that Sanderson (who own the original printing blocks) were re-launching some of their range of William Morris's wallpapers. On looking at their range I realized that *Trellis* and *Celandine* would both translate beautifully into needlepoint, and *Trellis* became my first adaptation for needlepoint.

I had already tried most forms of embroidery. I had also done a great deal of dressmaking and knitting, always to my own designs. I liked playing with colour and styles while sorting out the mathematical problems of rows and stitches. At the Royal School, I had been exposed to their fabulous collection of all types of embroidery, but I recognized I lacked the skill and patience required for many of them, such as goldwork and lace. I prefer making things that have a definite purpose.

Selina Winter at the Royal School introduced me to the technique of needlepoint, or canvaswork, and I completed a stitch sampler for a bedroom stool. Through this and the daily experience of helping customers with their choice of colours and designs to go in their homes, I became intrigued with the challenge of turning rigid squares of canvas into flowing designs with

apparently perfect curves. In this, needlepoint is not unlike knitting, and they are also similar in having a practical use. Then there are the colours; how they are used can alter the shape of a leaf, turning it over, making it curl or leaving it quite flat.

Every time I solved a problem, I learnt something. Now this aspect of designing gives me the greatest pleasure. The most logical approach to the lovely Morris designs would have been to use them for the surface embroidery or weaving for which they were originally intended, but for me there is a perverse pleasure in defeating the rigidity of the canvas while retaining as much of the design as possible.

Some designs have proved much easier to translate into needlepoint than others. Sometimes I draw the design directly on the canvas, sometimes on graph paper, so some start life as a painted canvas and others as a charted design.

I always have to decide at the outset the finished size of the article and, according to the intricacy of the design, how coarse a canvas I can afford to have while still permitting enough stitches to retain the detail. Sometimes, especially in the case of rugs that are stitched on coarse canvas, I have to leave out some details. The curves have to look as if they curve, in spite of the 'steps' taken by the stitches.

With tent stitch, there is a special problem: when the stitch, which is diagonal, is used for symmetrical curves, the stitches will lie better on one side than on the other. Fortunately, our eyes adjust and often 'see' what we want them to see, making a true symmetry where none exists.

Colours are just as important. I always have a framed-up piece of canvas to hand and use it like a sketch pad. The shades of wool must be stitched to get their true effect. Two colours held in your hand may seem perfect but could be indistinguishable when stitched. In general, colours in wool stitch darker than they look.

My first few designs I did entirely alone, but I am now lucky enough to have found Phyllis Steed, who draws beautifully and can produce immaculate line drawings from my wobbly sketches. I am also lucky to have found some really excellent embroiderers, whose stitching is a joy to behold and who can translate my ideas to canvas freehand. One day soon, perhaps, my canvas sketch pad will be superfluous, but it would be sad to lose it. I want to stay at the creative end of the action.

Canvas stitching is less taxing than surface embroidery and much harder-wearing. There is a repetitive peacefulness about needlepoint which makes it addictive. If the colours and shapes are good, you will have something lovely to look at, and also to use at the finish.

William Morris expressed this a hundred years ago:
If you want a golden rule that will fit
everybody, this is it: Have nothing in
your houses that you do not know to
be useful, or believe to be beautiful.

Right:
Detail of William Morris
Pomegranate wallpaper
from the Yellow Bedroom
at Cragside.

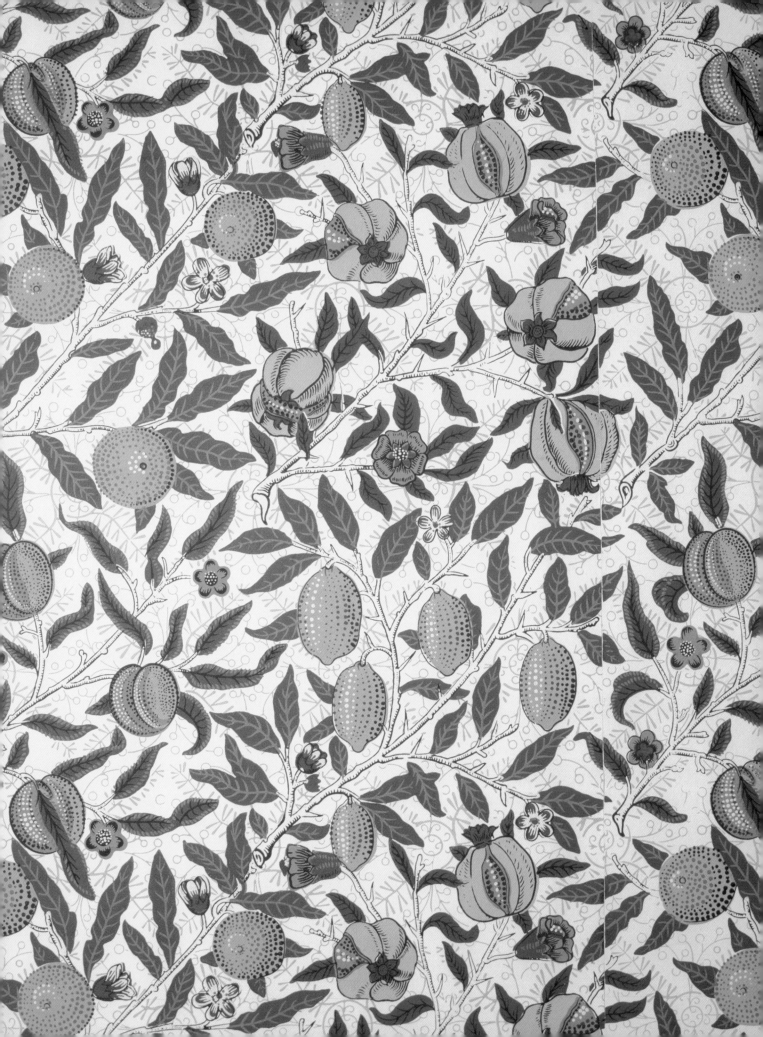

THE ARTS AND CRAFTS MOVEMENT

The Arts and Crafts Movement, from which most of my designs are taken, started as a gentle rebellion by a group of artists, designers and architects concerned by the poor standard of design they saw around them in the buildings and furnishings of Victorian England.

After the Industrial Revolution, Britain led the world as the most advanced industrial nation. The advantages of mechanization and mass production were, however, accompanied by the sacrifice of beauty and individuality and the loss of fulfilment for the maker. Speaking to a meeting of industrialists in 1880, William Morris (1834–1896), one of the most influential leaders of the Arts and Crafts Movement, voiced the problem:

(I) call on you to face the latest danger which civilization is threatened with, a danger of her own breeding: that men in struggling towards the complete attainment of all the luxuries of life for the strongest portion of their race should deprive the whole race of the beauty of life ...

Together with the author John Ruskin and the architect A W N Pugin, Morris advocated instead a return to the values of craftsmanship he saw and loved in the designs of the Middle Ages – 'that commoner work, in which all men once shared'.

William Morris was born into a comfortably wealthy family; throughout his life his own money had to help support his work. As a young man at Oxford University, he met Edward Burne-Jones and Dante Gabriel Rossetti, Pre-Raphaelite painters who were to remain his friends for the rest of his life. After university, Morris started training in the offices of the architect Philip Webb, but he was soon invited by Rossetti to join a scheme for decorating the interior of the Oxford Union Library. He quickly recognized his true talents as a designer; in Oxford also he met his wife, Janey, the dark, brooding model for Rossetti's most famous paintings.

Morris adored his wife but the marriage was an unhappy one; she turned away from him to Rossetti, and at their later home, Kelmscott Manor, they lived in a strange *ménage à trois*.

Their first married home (1860–65) was Red House in Bexleyheath, Kent, a new building commissioned from Philip Webb. The red-brick exterior, considered daring at the time, was completed in just over a year, but I suspect the furnishings took rather longer. Morris insisted on handmade furniture and hand-finished interiors, and Philip Webb, Rossetti and Burne-Jones were all involved. I like to think of the weekend parties at Red House with Morris's friends, painting the walls and stencilling the ceilings.

It was Morris's inability to find what he wanted ready-made for his home that caused him to set up his own company, Morris, Marshall, Faulkner & Co. ('the Firm'), in London in 1861. The enormous influence he exercised over design from the 1860s was mostly through the Firm.

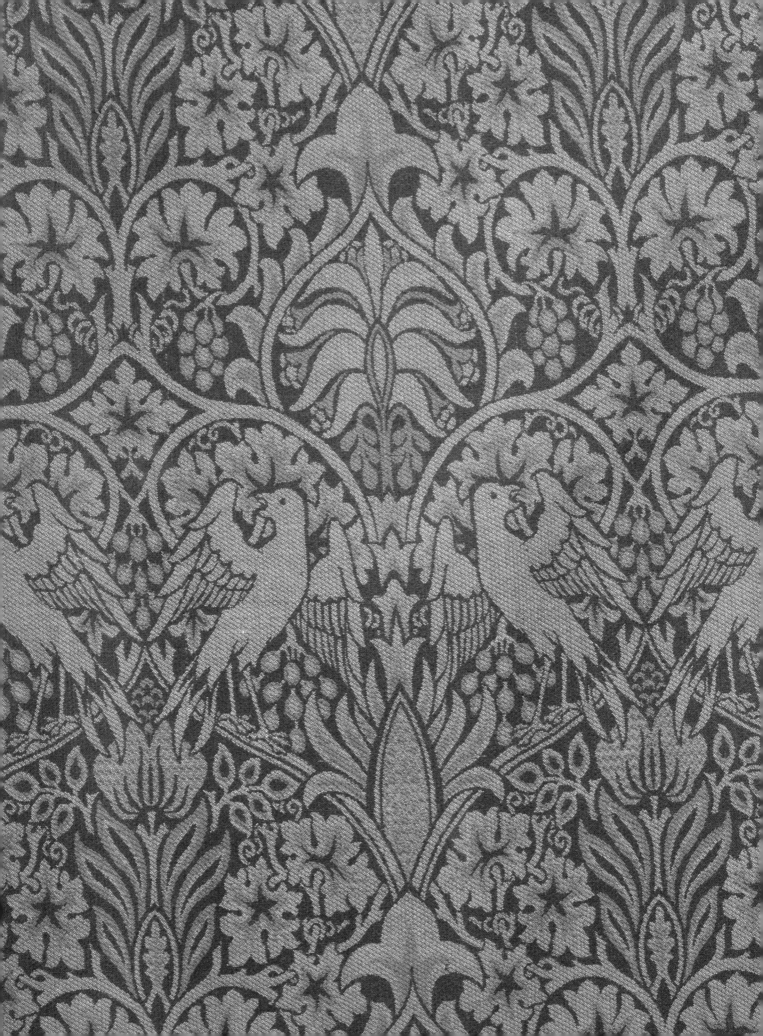

Wallpapers, furniture, stained glass, and later fabrics and then weaving were all produced under his guidance and often to his design. Morris' designs use clear bright colours, in contrast to the garish tones of the Berlin woolwork embroidery which was then in fashion.

He also worked closely with other leading Victorian designers, among them William De Morgan (1839–1917), whose Persian-coloured ceramic tiles depict fabulous beasts, sailing ships and exotic floral and bird designs. The rich glazes of the tiles are very difficult to capture in needlepoint, but I had to try.

I think of William Morris first and foremost as a pattern designer, and because he rediscovered the forgotten technique of indigo dyeing. But Morris was also a poet; he wrote several novels (the most famous is *News from Nowhere*); he even learnt Icelandic so that he could set about the task of translating the sagas. As if all this were not enough, he was also a brilliant and influential typographer, printing masterpieces such as the *Kelmscott Chaucer* at his own Kelmscott Press in the coach house of his London home, Kelmscott House, in Hammersmith.

Towards the end of his life, Morris became more and more involved in socialism, spending much of his time writing pamphlets and speaking at public meetings. It was the inevitable result of his search for beauty for all. 'What right have you', he lectured his well-fed audience of industrialists, 'to shut yourself up with beautiful form and colour when you make it impossible for other people to have any share in these things?' The failure of the Firm's ideals was that the handmade furnishings they produced could only be afforded by the rich.

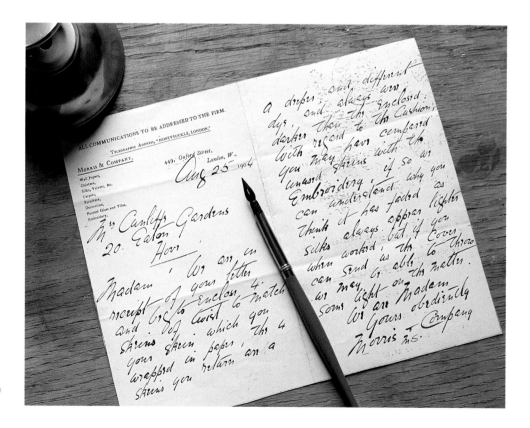

Right:
An original letter from Morris & Co., dated 1904, answering a customer's enquiry. It was kindly sent to me by a customer of mine in America.

Yet, when I think of William Morris, I sense that however much he may have felt unhappy with the time in which he lived, he must have been pleased with his achievements.

The Arts and Crafts Movement slowly became worldwide and later developed into the style now recognized as Art Nouveau. The name comes from a gallery, L'Art Nouveau, opened in Paris in 1895 by Samuel Bing and decorated by Frank Brangwyn. It displayed work by L. C. Tiffany, Henry van de Velde, Walter Crane, Aubrey Beardsley and many more. The Chicago World's Fair in 1893 exhibited designs by Tiffany & Co., and in the same year Frank Lloyd Wright set up his architectural practice in America. Back in England, the new *Studio* magazine illustrated the work of a rich variety of artists and designers, including C. F. A. Voysey and Frank Brangwyn.

In *News from Nowhere*, published in 1891, William Morris describes an ideal future society after an imaginary civil war in 1952. The central character in the story falls asleep in Victorian England and wakes in a world where handicrafts and machinery are in harmony. Someone he meets explains the new system:

> *The wares which we make are made because they are needed;*
> *men make for their neighbours' use as if they are making for*
> *themselves, not for a vague market of which they know nothing,*
> *and over which they have no control ... as we are not driven to*
> *make a vast quantity of useless things, we have time and*
> *resources enough to consider our pleasure in making them. All*
> *work which would be irksome to do by hand is done by*
> *immensely improved machinery; and in all work which it is a*
> *pleasure to do by hand, machinery is done without.*

Happily, there is no machine for needlepoint so we can take as great a pleasure in it as we choose. I hope you will derive as much enjoyment from developing these designs as I have in finding them for you.

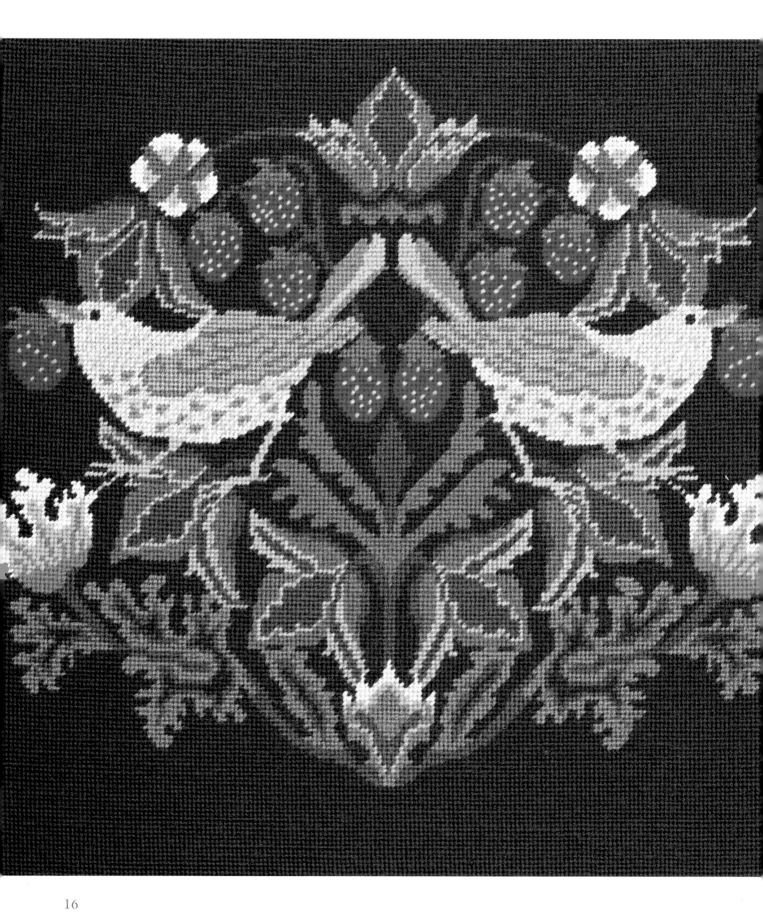

STRAWBERRY THIEF

This popular textile design by William Morris was printed at Merton Abbey in Surrey about 1883. Morris hated the lurid colours produced by the new aniline dyes. He wanted to re-create the colours of the historical textiles he loved, so he went to great trouble to research the techniques of vegetable dyeing. The indigo discharge method by which *Strawberry Thief* was produced was lengthy and complex, and I think Morris must have been extremely pleased with its success.

Sometimes a single Morris pattern can inspire a whole series of designs. In this case, different elements of the original fabric have been isolated and adapted in each of these three canvases. You might like to try your hand at creating a fourth design, with the second pair of birds reversed, back to back, and a flower motif in the centre.

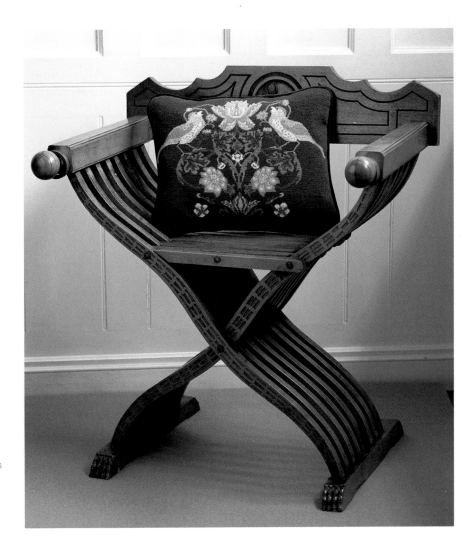

Left:
Strawberry Thief II.

Right:
This magnificent 'X' chair adds history as well as drama to *Strawberry Thief I*. It was brought from the East by the Beale family, the original owners of Standen, the house designed and decorated by Philip Webb and William Morris in 1892.

Strawberry Thief can be used for fitted cushions, chair seats or stools as you can easily adapt the proportions by working more or less background (see page 115). If you have difficulty deciding which of the 'thieves' you prefer, they work very well as a complementary set!

I was drawn to the large flowers between the birds in *Strawberry Thief I*. This was much more challenging than *Trellis*, my first project (page 40), and I wanted to try a three-dimensional object. I felt guilty about straying from Morris's original, and it took some thought before I could decide what had to be omitted. I could have left some leaves under the birds' tails, but they were not growing from anywhere logical so I left them out. Some of the finer foliage also had to be omitted as it would not have shown clearly when stitched.

After several drawings and experimental stitching sessions, I was reasonably happy. I had to blend two shades of wool in the needle for the markings on the birds and the seeds in the flowers to prevent them looking harsh and unnatural. The heavy outlines on the original fabric would have looked clumsy in tent stitch, so shading was used to achieve the same effect without straying too far from the original.

Strawberry Thief I was not an ideal shape for a chair seat: chairs are usually wider at the front. The second pair of birds in the original Morris print, however, sit conveniently above flowers that extend beyond them, so I used them for *Strawberry Thief II*. The colours are, for the most part, the same as the first *Strawberry Thief* design. At first, I was worried that the strawberries would be too bright for many people's houses, but this has proved to be the most popular of the three and I now think this is probably due to the red berries. Almost nothing was omitted from this part of the fabric; it is very true to Morris's original.

The idea of adding a third design to the *Strawberry Thief* set came some time after the first two, after both *Bird* (page 26) and *Bird and Lily* (page 30) had been created. Between the two birds featured in *Strawberry Thief II* is a lovely curving plant, and I do not know why I had not seriously considered it sooner. The whole design in *Strawberry Thief III* has had to be moved together as it was too wide if kept in the same proportion as the other two. The flowers at the base are also not as closely clustered in the original.

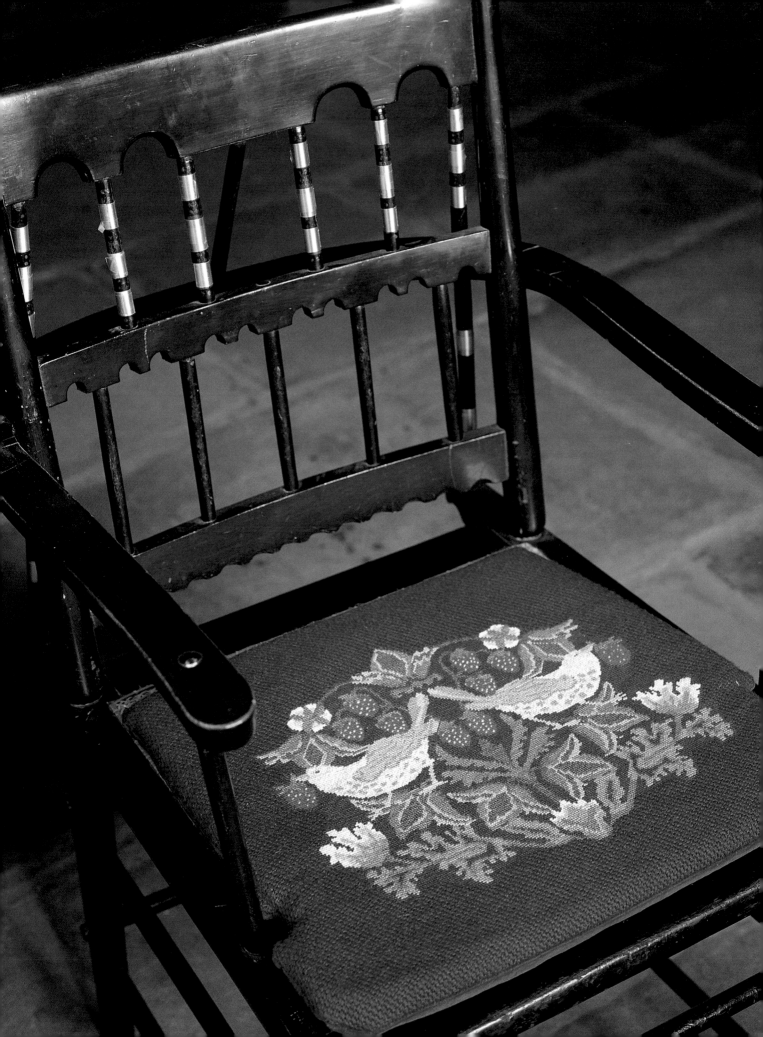

INSTRUCTIONS
Strawberry Thief I

Order of stitching

Refer to page 108 for how to prepare for stitching.

Strawberry Thief may be worked entirely in tent stitch using three threads of wool in the needle and for a chair seat or stool cover this is advisable as it is a hardwearing stitch. For a more decorative finish the background may be stitched in cashmere or gobelin filling (see page 118); you may then require more threads in the needle and you will need to adjust the length of your stitches to fit around the design. Five hanks of background wool are sufficient to stitch a total area of 33 x 43 cm (13 x 17 in). If you want to extend this area it is advisable to buy all the wool at the outset to ensure that it is all from the same dye lot.

Start in the centre. Each square represents a stitch. In order that the ivory colour should be discernable on the chart, it is depicted as a soft pinky beige. It is in the beak and body of the bird, and the highlights in the flowers. The birds' eyes and the veins in some leaves are in the blue generally used for the background. If you use a different background colour you will need to add a skein of blue to your list of wools. The fine speckling on the head, throat and body from the back leg to the tail is obtained by mixing one thread of 901 and two threads of 882 in the needle. See the hatched lines in the chart. The spots in the chart show more mixing of colours: one thread of 642 and two of 882 in the needle for the centre of some flowers.

In order to work the second half of this design, you might find it helpful to prop a mirror at right angles along the central line of the chart in order to 'see' the other side. Alternatively you can ask your local colour photocopy shop to make a mirror image of the chart.

Appleton crewel wool:

light pink (221) – 4 skeins	mid green (355) – 4 skeins
mid pink (222) – 4 skeins	dark green (356) – 4 skeins
dark pink (223) – 4 skeins	honey (692) – 1 skein
browny pink (204) – 2 skeins	golden brown (901) – 1 skein
pale green blue (642) – 1 skein	ivory (882) – 4 skeins
dark green blue (644) – 1 skein	▨ 2 threads (882) 1 thread (901)
light green (352) – 1 skein	⊡ 2 threads (882) 1 thread (642)

Design size:
- 156 x 225 stitches
- 28 x 41 cm (11 x 16 in)

Materials:
- 14-count single canvas, 10 cm (4 in) larger in width and height than the intended stitched area, including the background
- Size 20 tapestry needle
- Background: indigo blue (926) – 5 hanks, sufficient to extend the background to 33 x 43 cm (13 x 17 in)

Note: The background indigo blue is also used for the veins of the leaves and the birds' eyes. If you use a different background colour you will also need 1 skein of indigo blue (926).

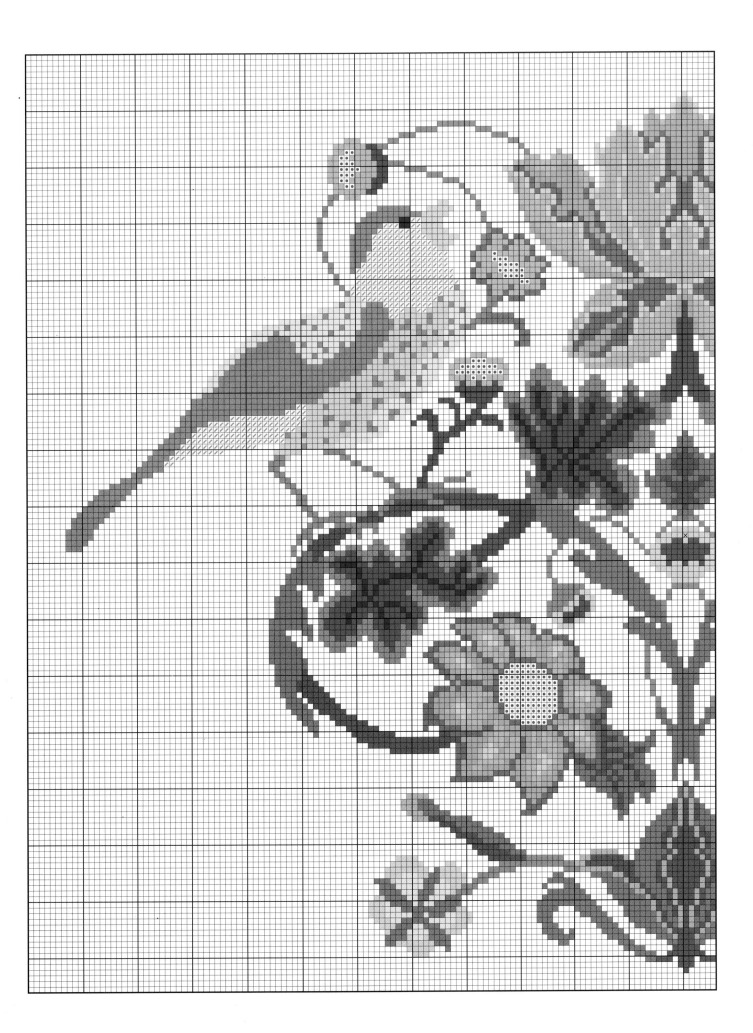

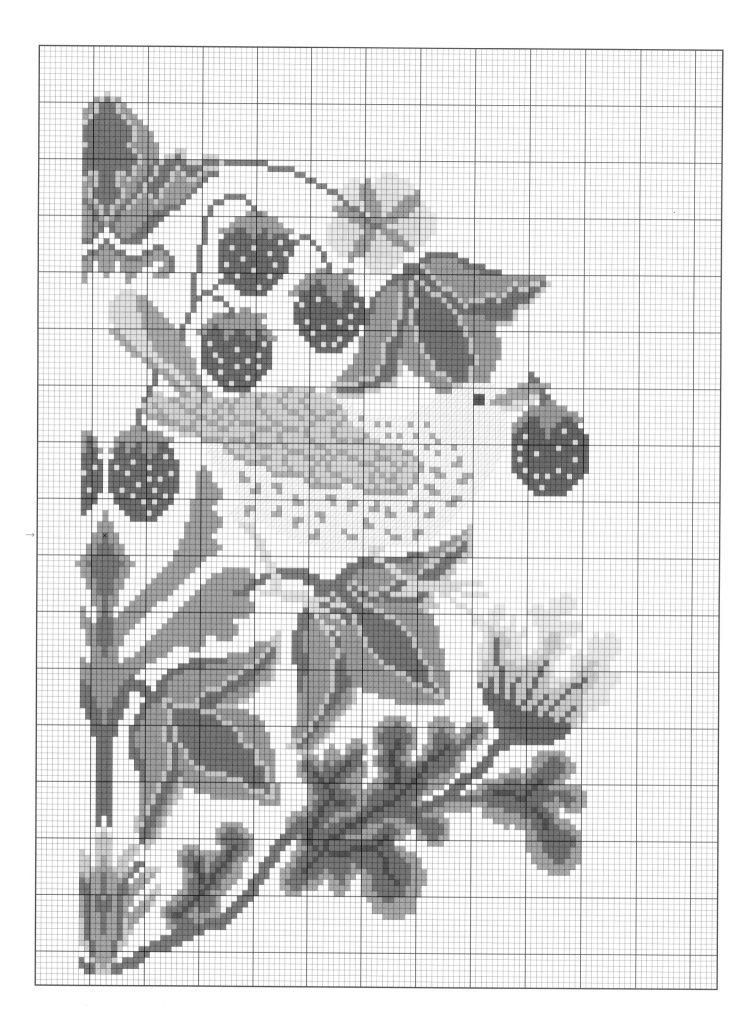

INSTRUCTIONS
Strawberry Thief II

Order of stitching

Refer to page 108 for how to prepare for stitching.

Strawberry Thief may be worked entirely in tent stitch using three threads of wool in the needle and for a chair seat or stool cover this is advisable as it is a hardwearing stitch. For a more decorative finish the background may be stitched in cashmere or gobelin filling (see page 118); you may then require more threads in the needle and you will need to adjust the length of your stitches to fit around the design.

Five hanks of background wool are sufficient to stitch a total area of 33 x 43 cm (13 x 17 in). If you want to extend this area it is advisable to buy all the wool at the outset to ensure that it is all from the same dye lot.

Start in the centre. Each square represents a stitch. In order that the ivory colour 882 should be discernable on the chart, it is depicted as a soft pinky beige in the flowers. The birds' eyes and veins in some leaves are in the blue generally used for the background. If you decide on a different colour for the background you will need to add a skein of blue to your list of wools. The fine speckling on the bird's body is obtained by mixing one thread of honey (692) and two threads of ivory (882) in the needle. See the hatched lines in the chart.

In order to work the second half of this design, you might find it helpful to prop a mirror at right angles along the central line of the chart in order to 'see' the other side. Alternatively you can ask your local colour photocopy shop to make a mirror image of the chart.

Design size:
- 156 x 189 stitches
- 28 x 34 cm (11 x 13½ in)

Materials:
- 14-count single canvas, 10 cm (4 in) larger in width and height than the intended stitched area, including the background
- Size 20 tapestry needle

Appleton crewel wool:

- light pink (221) – 1 skein
- dark pink (223) – 1 skein
- light green blue (641) – 1 skein
- mid green blue (642) – 4 skeins
- dark green blue (644) – 2 skeins
- light green (352) – 2 skeins

- mid green (355) – 4 skeins
- dark green (356) – 4 skeins
- honey (692) – 2 skeins
- golden brown (901) – 1 skein
- ivory (882) – 4 skeins
- 2 threads (882) 1 thread (692)

- scarlet (504) – 2 skeins
- Background: indigo blue (926) – 5 hanks, sufficient to extend the background to 33 x 43 cm (13 x 17 in)

Note: The background indigo blue is also used for the veins of the leaves and the birds' eyes. If you use a different background colour you will also need 1 skein of indigo blue (926).

INSTRUCTIONS
Strawberry Thief III

Order of stitching

Refer to page 108 for how to prepare for stitching.

Strawberry Thief may be worked entirely in tent stitch using three threads of wool in the needle and for a chair seat or stool cover this is advisable as it is a hardwearing stitch. For a more decorative finish, the background may be stitched in cashmere or gobelin filling (see page 118); you may then require more threads in the needle and you will need to adjust the length of your stitches to fit around the design. Five hanks of background wool are sufficient to stitch a total area of 33 x 43 cm (13 x 17 in). If you want to extend this area it is advisable to buy all the wool at the outset to ensure it is all from the same dye lot.

Start in the centre. Each square represents a stitch. In order that the ivory colour should be discernable on the chart, it is depicted as a soft pinky beige in the flowers. The birds' eyes, veins in some leaves and the seeds in the plant at the top centre are in the blue generally used for the background. If you decide on a different colour for the background you will need to add two skeins of blue to your list of wools. The fine speckling is obtained by mixing one thread of honey (692) and two threads of ivory (882) in the needle on the body of the bird. See the hatched lines in the chart. The spots in the chart show more mixing of colours: one thread of mid green blue (642) and two of ivory (882) in the needle for the centre of three of the flowers.

In order to work the second half of this design, you might find it helpful to prop a mirror at right angles along the central line of the chart in order to 'see' the other side. Alternatively you can ask your local colour photocopy shop to make a mirror image of the chart.

Appleton crewel wool:

- light pink (221) – 1 skein
- dark pink (223) – 1 skein
- light green blue (641) – 4 skeins
- mid green blue (642) – 4 skeins
- dark green blue (644) – 4 skeins
- light green (352) – 4 skeins
- mid green (355) – 4 skeins
- dark green (356) – 4 skeins
- honey (692) – 4 skeins
- golden brown (901) – 1 skein
- ivory (882) – 4 skeins
- ▨ 2 threads (882) 1 thread (692)

Design size:
- 159 x 225 stitches
- 29 x 41 cm (11½ x 16 in)

Materials:
- 14-count single canvas, 10 cm (4 in) larger in width and height than the intended stitched area, including the background
- Size 20 tapestry needle

- ⊙ 2 threads (882) 1 thread (642)
- scarlet (504) – 2 skeins
- Background: indigo blue (926) – 5 hanks, to extend the background to 33 x 43 cm (13 x 17 in)

Note: The indigo blue is also used for the leaves and birds' eyes. If you use a different background colour you will also need 1 skein of indigo blue (926).

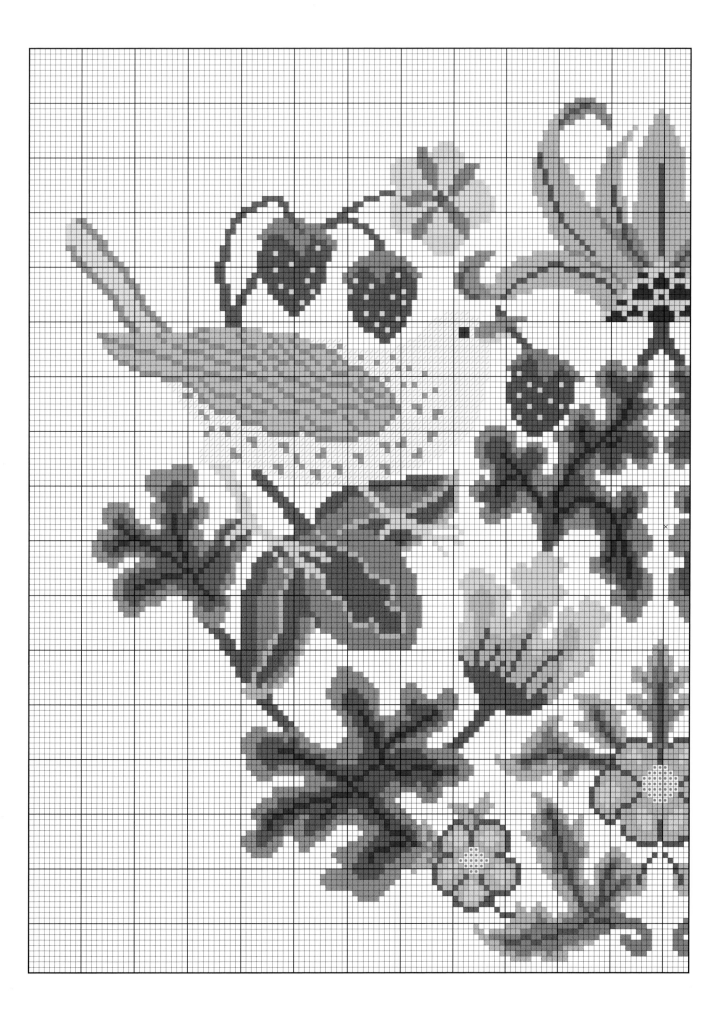

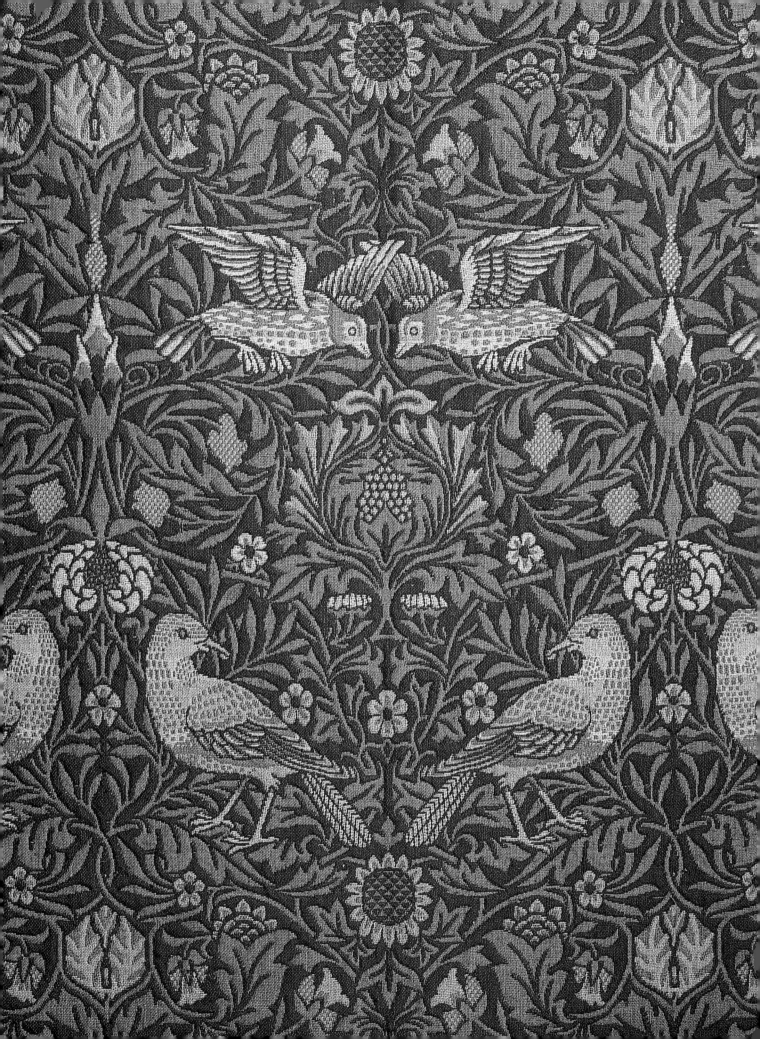

BIRD

Strawberry Thief proved so popular that my customers began asking for other bird designs so that they could complete sets of chair covers. William Morris produced many designs incorporating birds, but this one seemed to offer a natural chair seat shape without altering the original design too much. However, there were problems. I had seen a partially painted drawing by Morris, showing two brightly coloured birds and green leaves. The finished tapestries, however, had a very dark blue background, with flat-looking leaves in a lighter blue, and some in light green.

When I tried stitching this combination on canvas, it simply didn't work. Morris's hangings, beautiful as they are, rely largely on their texture. I also wanted a design that would complement *Strawberry Thief*. I compromised and introduced a few shades that were closer to my earlier designs. I made the birds as bright as in the original painting, and the flowers pink and white. I am still unhappy with the orb, or pomegranate, between the birds – it is not as pretty as the original.

Left:
Bird was William Morris' first woven hanging to include birds. It was originally designed to hang in the drawing room at Kelmscott House, Morris's town house in Hammersmith, West London.

Right:
This chaise longue in the Green Room at Kelmscott Manor is covered in the original *Bird* fabric, which you can see has a larger design than my cushion. In the background is a De Morgan tile, designed for the P&O liner 'India' in 1896.

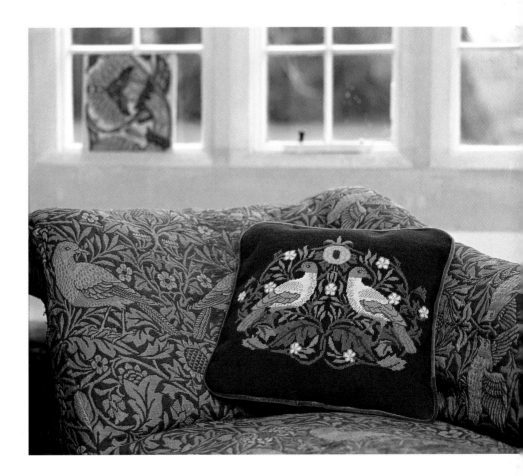

INSTRUCTIONS
Bird

Order of stitching

Refer to page 108 for how to prepare for stitching.

Bird may be worked entirely in tent stitch using three threads of wool in the needle and for a chair seat or stool cover this is advisable as it is a hardwearing stitch. For a more decorative finish the background may be stitched in cashmere or gobelin filling (see page 118); you may then require more threads in the needle and will need to adjust the length of your stitches to fit around the design. Five hanks of background wool are sufficient to stitch a total area of 33 x 43 cm (13 x 17 in). If you want to extend this area it is advisable to buy all the wool at the outset to ensure it is all from the same dye lot.

Start in the centre. Each square represents a stitch. The birds' eyes and the centre of the gold pomegranate at top centre are in the dark blue (926) generally used for the background. If you decide on a different colour for the background you will need to add a skein of blue to your list of wools.

The fine speckling is obtained by mixing two colours in the needle. For the the top part of the wings blend one thread of 522 and two threads of 521 in the needle. For the breast, blend one thread of 222 with two threads of 877 – see the blue and the pink-hatched lines in the chart. The centre of the pomegranate at top centre is worked in one thread of the background 926 and two of 642.

In order to work the second half of this design you might find it helpful to prop a mirror at right angles along the central line of the chart in order to 'see' the other side. Alternatively you can ask your local colour photocopy shop to make a mirror image of the chart.

Design size:
- 143 x 201 stitches
- 27 x 37 cm (10½ x 14½ in)

Materials:
- 14-count single canvas, 10 cm (4 in) larger each way than the size of the required worked area, including the background
- Size 20 tapestry needle

Appleton crewel wool:

pale yellow (471) – 1 skein	light green (401) – 4 skeins	pale turquoise (522) – 2 skeins
autumn yellow (473) – 1 skein	light blue green (642) – 4 skeins	Background: indigo (926) – 5 hanks
pale pastel pink (877) – 2 skeins	mid blue green (644) – 1 skein	(2X) 877, (1X) 222
mid pink (222) – 2 skeins	darkest blue green (645) – 2 skeins	(2X) 521 – 1 skein, (1X) 522
dark pink (223) – 2 skeins	mid slate blue (155) – 2 skeins	(2X) 642, (1X) 926

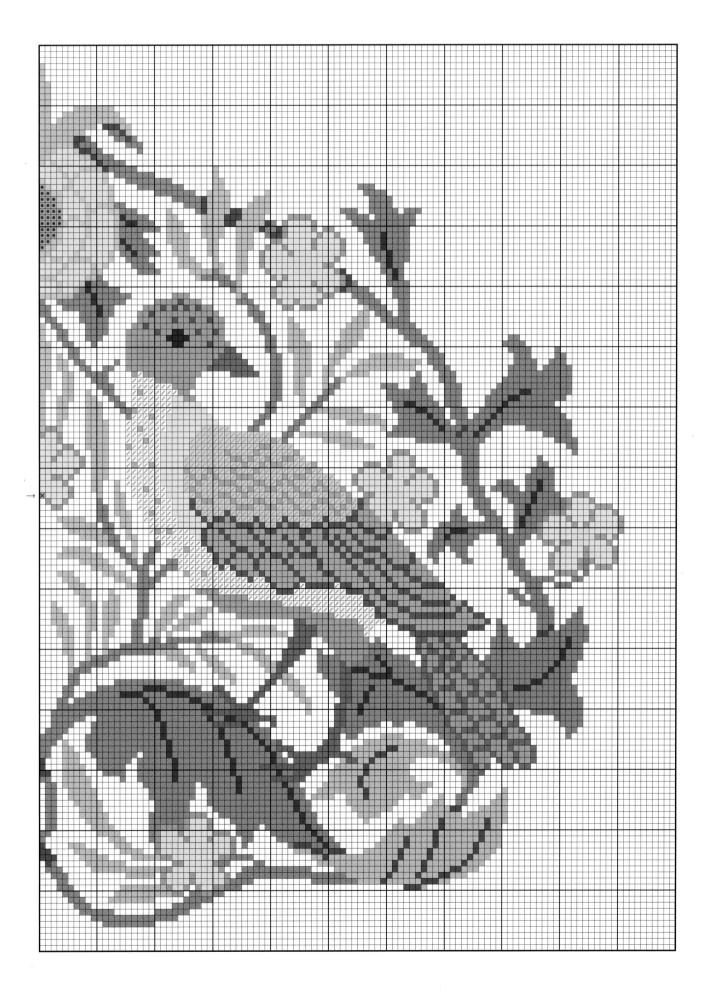

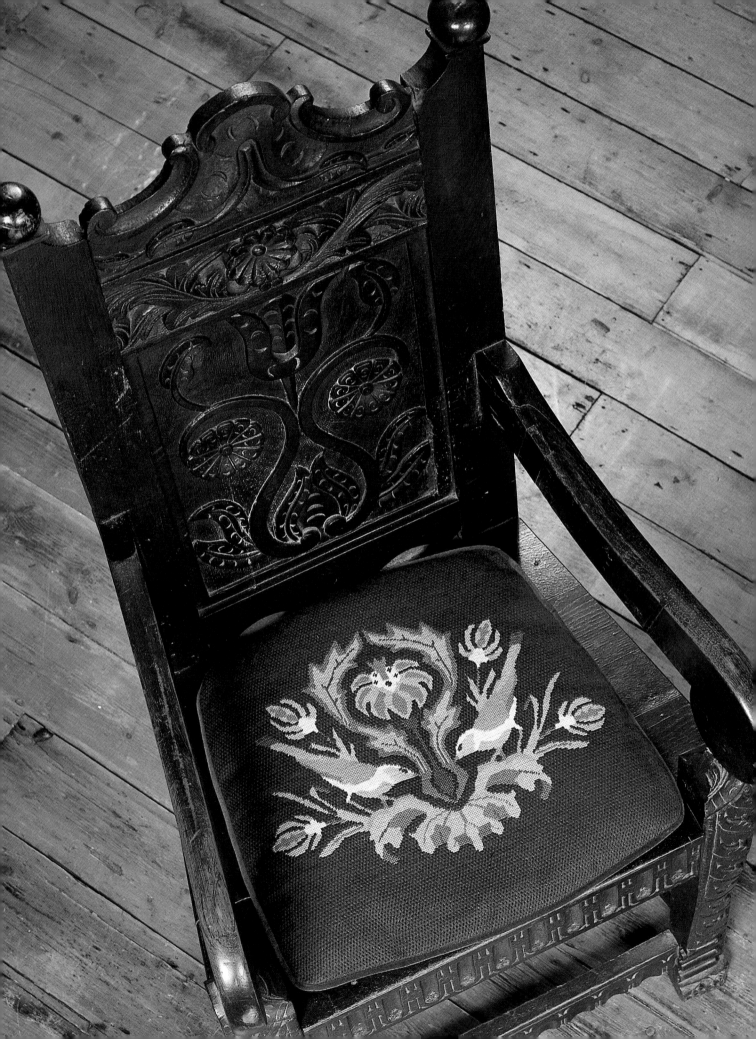

BIRD AND LILY

This was another attempt to satisfy the demand for a set of bird chair seats. Although it is not taken directly from William Morris, there are elements of his style – in the lily, for example. The 'feel' of *Bird and Lily* is also Morris; perhaps slightly less detailed but a clear, strong design which works well with the other bird patterns.

There were no problems with this design. I asked Phyllis Steed, the artist who line draws most of my sketches, to produce a new bird in the same mode as the others. We chose the colours together, I stitched sample areas to see how they would work, and a new design was born.

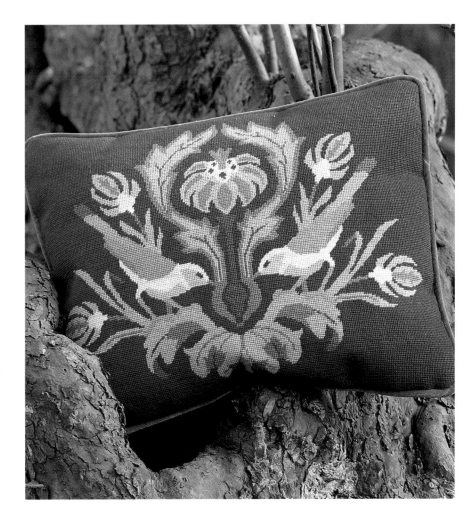

Left:
This design is a good choice to soften a Gothic-style chair.

Right:
Bird and Lily tucked comfortably in one of the remaining apple trees from the original orchard at the Red House in Bexleyheath, Kent. The orchard was already established when Philip Webb built the house for William and Janey Morris as their first home in 1860.

INSTRUCTIONS
Bird and Lily

Order of stitching

Refer to page 108 for how to prepare for stitching.

Bird and Lily may be worked entirely in tent stitch using three threads of wool in the needle and for a chair seat or stool cover this is advisable as it is a hard wearing stitch. For a more decorative finish the background may be stitched in cashmere or gobelin filling (see page 118); you may then require more threads in the needle and you will need to adjust the length of your stitches to fit around the design. Five hanks of background wool are sufficient to stitch a total area of 33 x 43 cm (13 x 17 in). If you want to extend this area it is advisable to buy all the wool at the outset to ensure it is all from the same dye lot.

Start in the centre. Each square represents a stitch. Please note that, in order that the ivory colour 882 should be discernable on the chart, it is depicted as a soft beige in the flowers and birds. Note that the birds' eyes and the anthers in the lily (top centre) are in the blue generally used for the background. If you decide on a different colour for the background you will need to add a skein of blue to your list of wools.

In order to work the second half of this design you might find it helpful to prop a mirror at right angles along the central line of the chart in order to 'see' the other side. Alternatively you can ask your local colour photocopy shop to make a mirror image of the chart.

Design size:
- 163 x 219 stitches
- 29 x 39 cm (11½ x 15½ in)

Materials:
- 14-count single canvas, 10 cm (4 in) larger in width and height than the intended stitched area, including the background
- Size 20 tapestry needle

Appleton crewel wool:

- light blue green (641) – 1 skein
- mid blue green (642) – 1 skein
- dark blue green (644) – 1 skein
- light green (352) – 4 skeins
- mid green (355) – 4 skeins

- dark green (356) – 4 skeins
- light yellow (692) – 1 skein
- light pink (221) – 4 skeins
- dark pink (223) – 4 skeins
- browny pink (204) – 4 skeins

- ivory (882) – 4 skeins
- Background: dark blue (926) – 5 hanks, sufficient to extend the background to 33 x 43 in (13 x 17 in)

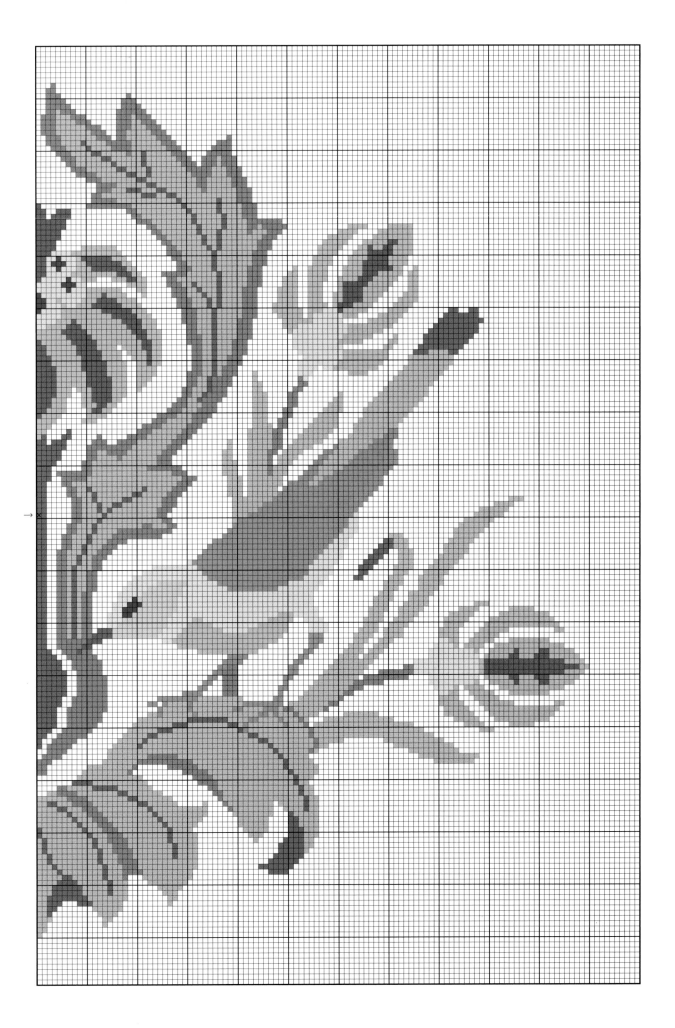

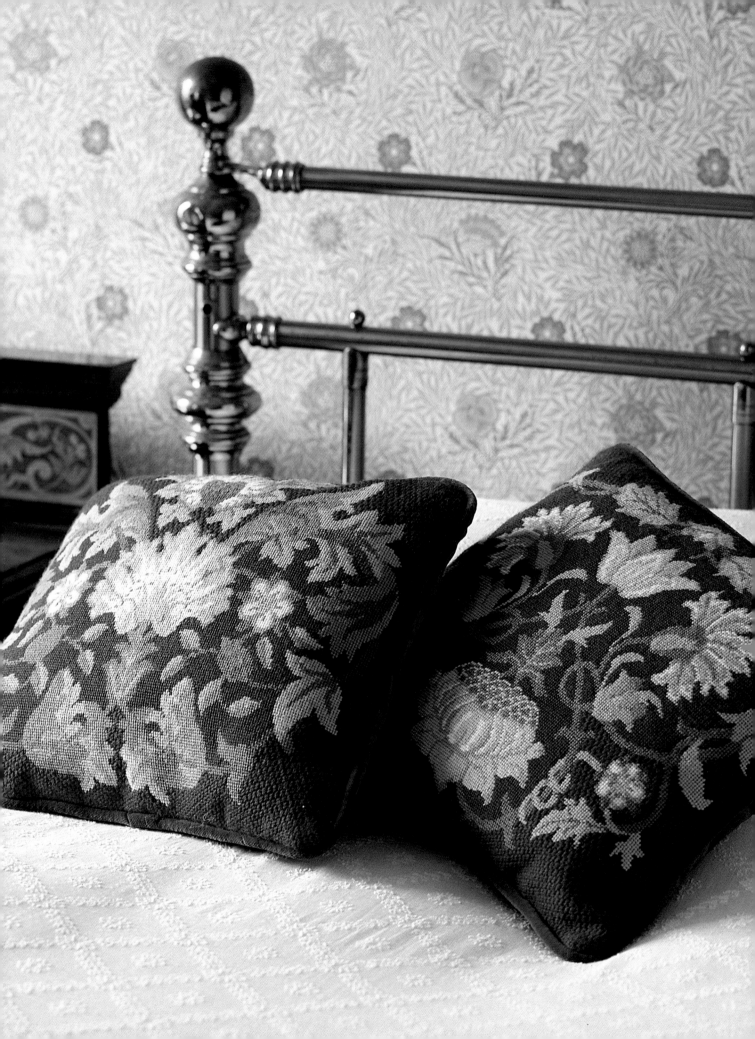

LODDEN

Lodden is one of William Morris' most complex textile designs. I admire it enormously – it is intricate without looking contrived. It has four distinct centres, intertwined and blended so cleverly that it took me a while to isolate them. I have used the two more dominant sections, and have tried to separate them from the rest of the design without losing the flow and feel of the original.

I was again forced to change some colours. The leaves in Morris's original simply did not convert into needlepoint. I made the leaves a little more natural, so that our eyes and knowledge of plants feed the imagination and create an impression of realistic foliage with sunlight playing upon it.

The stems presented a similar problem. In the original several are shown in outline but, unless I used a much finer canvas, this could not be reproduced in needlepoint. The solution was to make the stems green, which went with the more natural leaves of the needlepoint.

The original textile, still sold at Liberty in London, has a light background, similar to the version shown on the frame below. The needlepoint can be stitched with a dark background, either to match a *Strawberry Thief* set or simply because it is more practical for a chair seat.

Especially for this book, I made a miniature version of *Lodden* to cover a doll's chair (see page 6).

Left:
Lodden I and II together in a bedroom at Standen, in East Grinstead. The house was built by Phillip Webb and many of the furnishings came from Morris & Co. The *Powdered* wallpaper in the background was reprinted recently by Sanderson for the National Trust, using Morris's original blocks.

Right:
Just completed, *Lodden I* leans against one of the original apple trees in the garden of Red House. Over a hundred years old, this tree was there when William Morris and his family lived in the house (1860–5).

INSTRUCTIONS
Lodden I

Order of stitching

Refer to page 108 for how to prepare for stitching.

Lodden may be worked entirely in tent stitch using three threads of wool in the needle and for a chair seat or stool cover this is advisable as it is a hardwearing stitch. For a more decorative finish the background may be stitched in cashmere or gobelin filling (see page 118); you may then require more threads in the needle and will need to adjust the length of your stitches to fit around the design.

Five hanks of background wool are sufficient to stitch a total area of 33 x 43 cm (13 x 17 in). If you want to extend this area it is advisable to buy all the wool at the outset to ensure it is all from the same dye lot. Both the dark blue (926) and the light grey-blue (875) work beautifully with this design.

Start in the centre. Each square represents a stitch. In order to work the second half of this design you might find it helpful to prop a mirror at right angles along the central line of the chart in order to 'see' the other side.

Alternatively you can ask your local colour photocopy shop to make a mirror image of the chart.

Design size:
■ 158 x 197 stitches
■ 28.5 x 35.5 cm (11¼ x 14 in)

Materials:
■ 14-count single canvas, 10 cm (4 in) larger in width and height than the intended stitched area, including the background
■ Size 20 tapestry needle

Appleton crewel wool:

▨ light bluey pink (221) – 4 skeins

▨ mid bluey pink (222) – 1 skein

▨ dark bluey pink (223) – 1 skein

▨ light browny pink (202) – 4 skeins

▨ darker browny pink (204) – 2 skeins

▢ pale pastel pink (877) – 2 skeins

▨ greeny yellow (331) – 3 skeins

▨ light green (352) – 5 skeins

▨ blue-green (643) – 4 skeins

▨ dark grey-green (293) – 4 skeins

▢ Background: either dark blue (926) or light grey-blue (875) – 5 hanks for a background area of 33 x 43 cm (13 x 17 in)

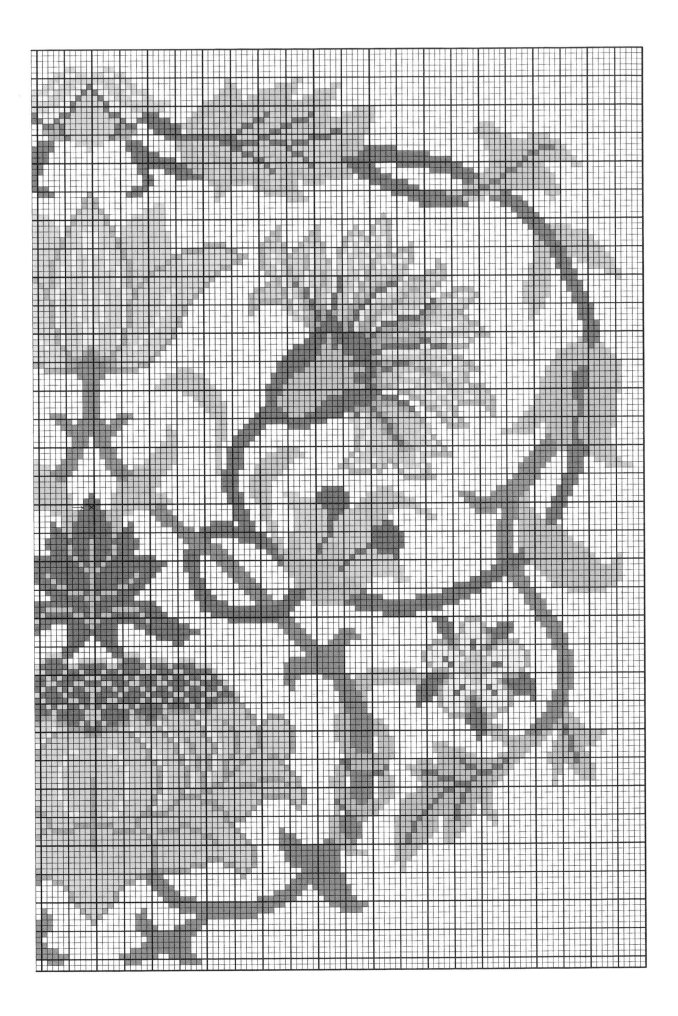

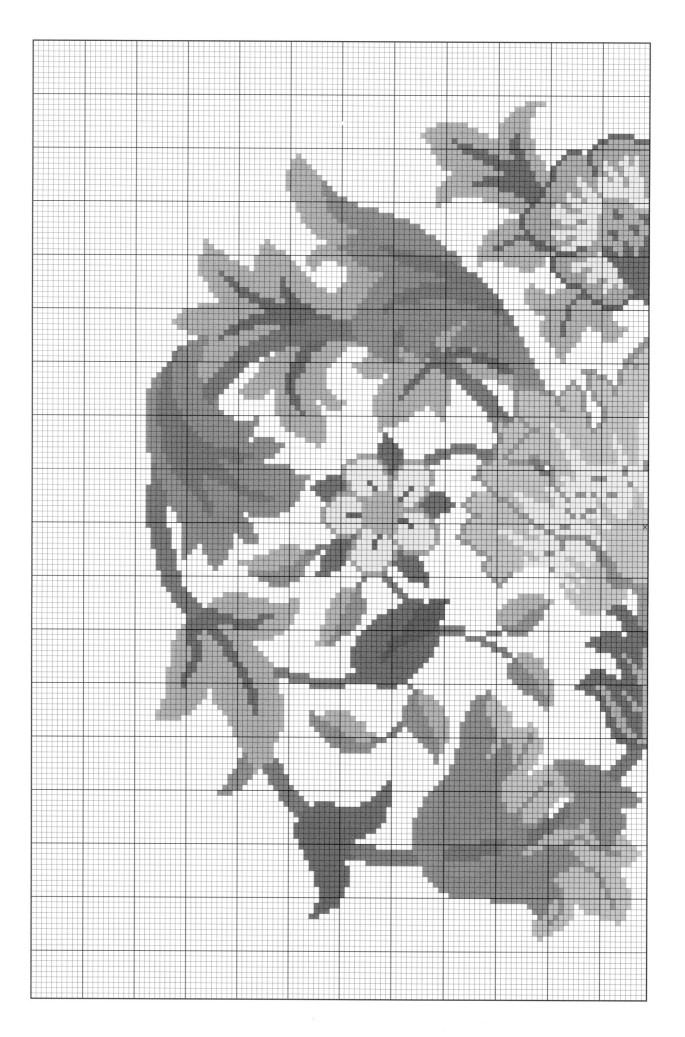

INSTRUCTIONS
Lodden II

Order of stitching

Refer to page 108 for how to prepare for stitching.

Lodden II may be worked entirely in tent stitch using three threads of wool in the needle and for a chair seat or stool cover this is advisable as it is a hard wearing stitch. For a more decorative finish the background may be stitched in cashmere or gobelin filling (see page 118); you may then require more threads in the needle and you will need to adjust the length of your stitches to fit around the design.

Five hanks of background wool are sufficient to stitch a total area of 33 x 43 cm (13 x 17 in). If you want to extend this area it is advisable to buy all the wool at the outset to ensure it is all from the same dye lot. Both the dark blue (926) and the light grey-blue (875) work beautifully with this design.

Start in the centre. Each square represents a stitch.

In order to work the second half of this design you might find it helpful to prop a mirror at right angles along the central line of the chart in order to 'see' the other side. Alternatively you can ask your local colour photocopy shop to make a mirror image of the chart.

Design size:
- 157 x 193 stitches
- 28.5 x 35.5 cm (11¼ x 14 in)

Materials:
- 14-count single canvas, 10 cm (4 in) larger in width and height than the intended stitched area, including the background
- Size 20 tapestry needle

Appleton crewel wool:

- mid bluey pink (222) – 1 skein
- dark bluey pink (223) – 1 skein
- light browny pink (202) – 2 skeins
- darker browny pink (204) – 1 skein
- pale pastel pink (877) – 2 skeins
- greeny yellow (331) – 1 skein

- pale green (352) – 4 skeins
- dark clear green (354) – 4 skeins
- blue-green (643) – 4 skeins
- dark grey-green (293) – 4 skeins
- Background: *either* dark blue (926) or light grey-blue (875) – 5 hanks if the background area is 33 x 43 cm (13 x 17 in)

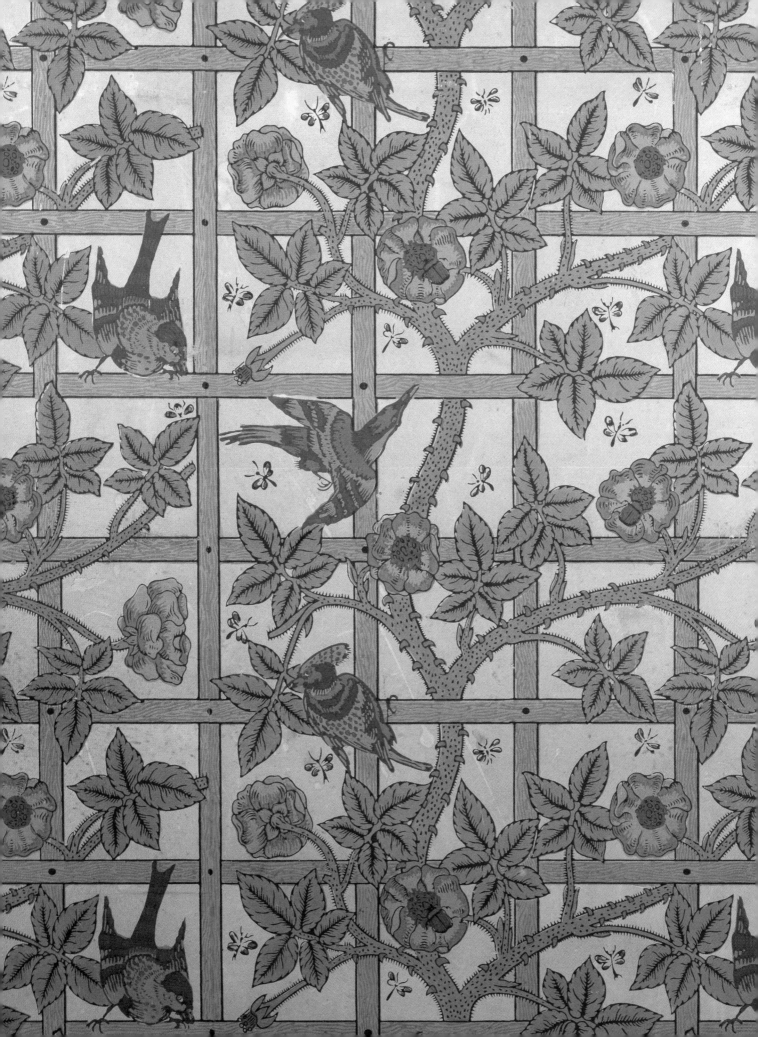

TRELLIS

This was the first William Morris design I attempted to adapt, and probably the easiest. It was also Morris's own first wallpaper design, believed to have been inspired by the rose trellis in his garden at Red House, Bexleyheath, where he spent the early years of his married life (1860–1865). I had seen the wallpaper in Sanderson in London, the perfect square for a cushion. I adore the rigidity of the wood softened by the entwining roses, and the birds (drawn by Philip Webb, the architect of the Red House) add a surprising splash of colour.

Sanderson still produce the hand-blocked *Trellis* wallpaper in two colourways, and at Kelmscott Manor I found yet another version, with yellow roses.

It was a simple matter to reduce the scale to an appropriate cushion size, draw it onto canvas and stitch the colours in to see if they worked. I wanted to give the feel of the wood grain, so I used straight gobelin filling stitch for the trellis itself. The roses are beautiful, and appear in many of Morris' later designs; they are slightly shaded. I was able to match the wallpaper very closely, and it looked exactly as I wanted it to.

Left:
This colourway of the *Trellis* design can be seen at Standen. Sanderson are currently producing two more versions in their hand-blocked range of Morris wallpapers.

Right:
The *Trellis* cushion on William Morris's own chair in the Old Kitchen at Kelmscott Manor, where many of his possessions and designs are displayed.

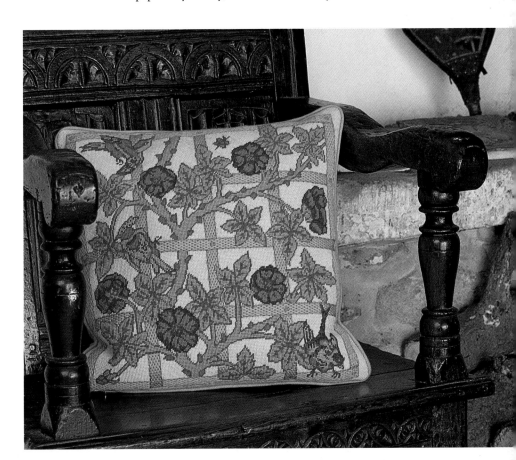

INSTRUCTIONS
Trellis

Order of stitching

Refer to page 108 for how to prepare for stitching.

After locating the centre, you may find it helpful to draw in the lines of trellis, marking them with a hard pencil, and use these grid lines for reference.

The majority of *Trellis* is worked in tent stitch using three threads of wool in the needle. The trellis itself is worked in gobelin filling using four threads in the needle (see page 118).

Start in the centre. Each square represents a stitch. Stitch the design first, then the nails, then the trellis and finally the background area.

As gobelin filling is a straight rather than a diagonal stitch, it lies between the canvas threads rather than over them. It would appear from the chart that there are two rows of outline grey 983 and six rows of putty 984 in between, but in fact you will find that there is room for seven rows of 984. The trellis consists of nine rows in all. The stitch direction follows the same direction as the trellis (vertically or horizontally) as would the grain of wood. Where one length of trellis passes behind another piece, or where the design lies on top of the trellis, you will need to shorten some stitches so that they appear to pass underneath.

Design size:
- 192 x 192 stitches
- 35.5 x 35.5 cm (14 x 14 in)

Materials:
- 14-count single canvas,
 50 x 50 cm (20 x 20 in)
- Size 20 tapestry needle

Appleton crewel wool:

- light blue (562) – 1 skein
- mid blue (564) – 1 skein
- dark blue (565) – 2 skeins
- pink (205) – 2 skeins
- mid pink (207) – 2 skeins
- dark pink (209) – 2 skeins
- honey (695) – 1 skein
- brown (697) – 1 skein
- putty (984) – 1 hank
- grey (983) – 4 skeins
- light green (352) – 1 hank
- dark green (335) – 1 hank
- Background: ivory (882)
 – 1½ hanks

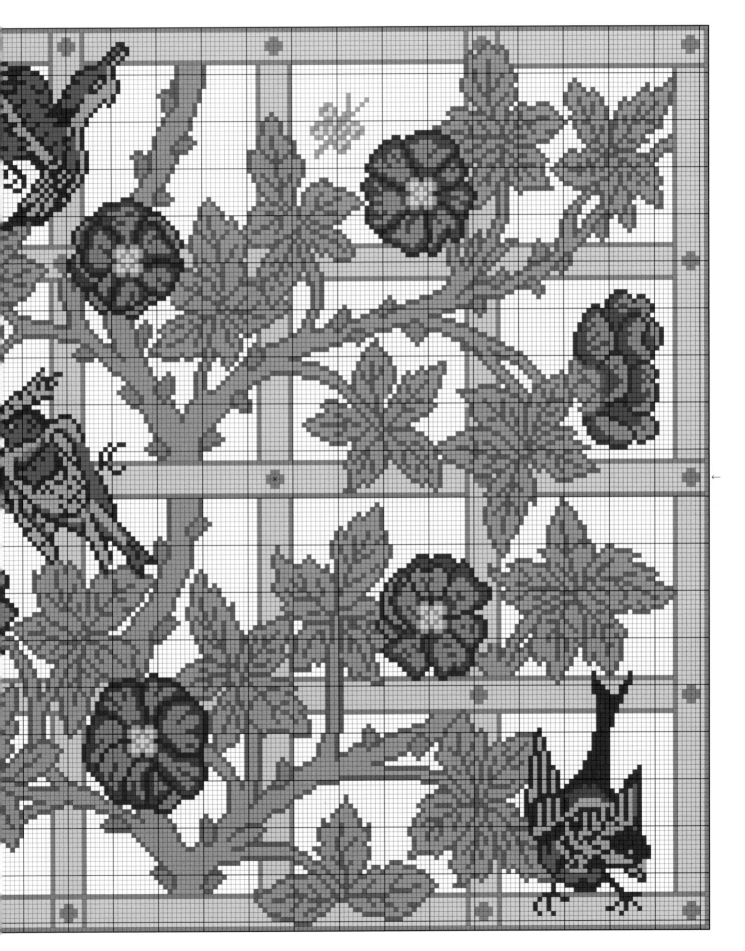

TIFFANY WINDOW

This design is taken from a section of a fabulous domed skylight made about 1900 by the famous American glass artist Louis Comfort Tiffany (1848–1933). Son of Charles Tiffany, the founder of Tiffany & Co., he was known for his iridescent stained glass and the famous 'Favrile' lamps of the 1890s. How I envy the owner of the house who commissioned such a work of art for his garden room!

Only part of the circular design could be used, so I have shortened the branches to bring the two groups of leaves and flowers closer together. I think the leading round the flowers works well, and the shading of the sky. We have nearly achieved the iridescence of the original, with its feeling of light penetrating the white clouds.

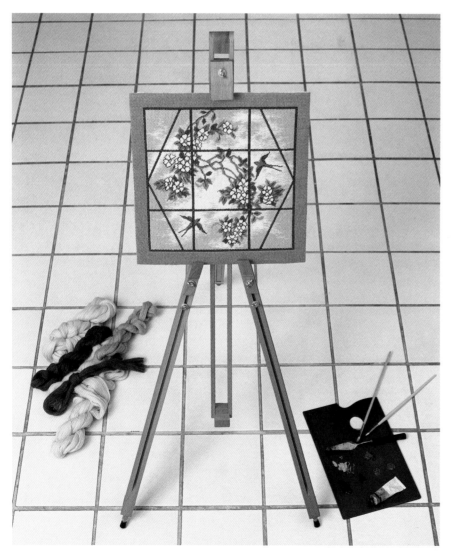

Right:
When it comes to stitching the sky, feel free to blend the colours of the sky and clouds as you wish – 'painting' in thread is fun!

Left:
This photograph of *Tiffany Window* shows the strong lines and angles of this unusual design.

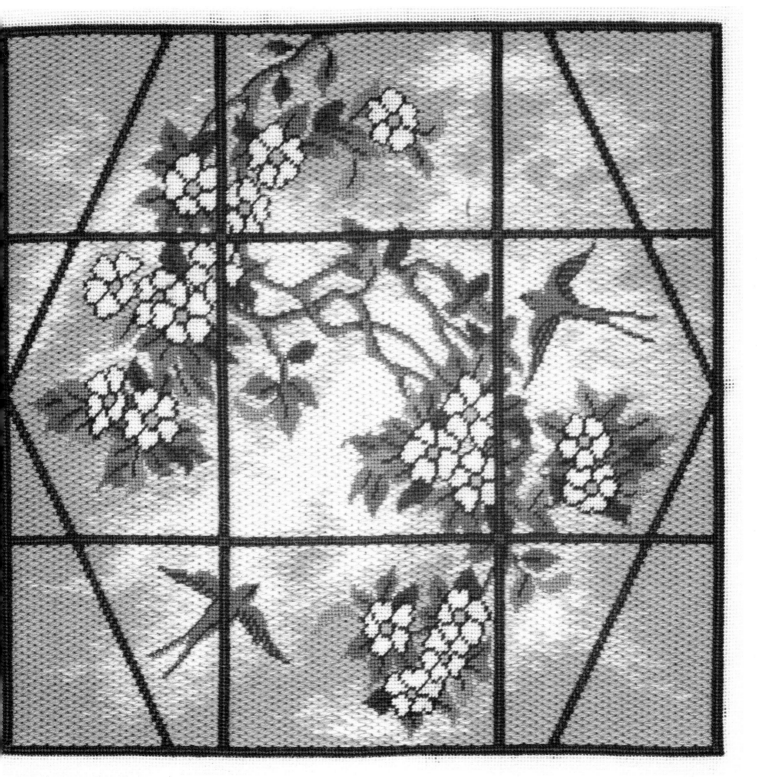

INSTRUCTIONS
Tiffany Window

Order of stitching

Refer to page 108 for how to prepare for stitching.

The foreground consisting of the trees, flowers, birds and leading is worked in tent stitch using two threads of wool in the needle. The background sky may also be worked in tent stitch but is shown here using gobelin filling stitched horizontally (see page 118). As this requires three threads of wool in the needle it offers more scope for shading, giving the clouds a realistic quality.

Find the centre in the sky. Do not stitch this yet but count from here either to the branch above or to the nearest leaves and start stitching, each square represents one tent stitch. When you reach a part of the window leading you might find it helpful to complete all the straight leading as it provides many points of reference for the rest of the design. Complete the design before starting the sky. The shading of the sky is achieved by using three strands of wool in the needle and varying the colours, using gobelin filling horizontally over four threads of canvas.

Start with the solid cream clouds in the centre. Make sure the edges of the clouds are not too straight. Complete the rest of the sky radiating outwards from the cream and changing the colours: mixing the wools in the needle. Use the photograph for reference but let the configuration of the clouds be your own choice. Possible variations are: three creams; two creams and one pastel blue; three pastel blues; two pastel blues and one pale blue, and so on. Adjust the length of the stitches to fit around the design.

The 3 cm (1¼ in) brown surround shown here required one extra hank each of 762 and 901 crewel wool. Two strands of 762 and one of 901 were used for gobelin filling stitched vertically.

Design size:
- 207 x 219 stitches
- 29 x 30.5 cm (11½ x 12 in)

Materials:
- 18-count single canvas, 41 x 41 cm (16 x 16 in)
- Size 22 tapestry needle

Appleton crewel wool:

- pale yellow green (251) – 1 skein
- darker blue-green (402) – 1 skein
- light true green (543) – 1 skein
- mid true green (544) – 1 skein
- dark green (545) – 1 skein
- very dark green (547) – 1 skein
- lighter grey (974) – 1 skein
- dark grey (976) – 1 hank
- light brown (764) – 1 skein
- dark brown (304) – 1 skein
- yellow (553) – 1 skein
- light turquoise (564) – 1 skein
- dark turquoise (488) – 1 skein
- white (991) – 2 skeins
- cream (882) – 1 hank
- pastel blue (875) – 1 hank
- pale blue (562) – 2 hanks

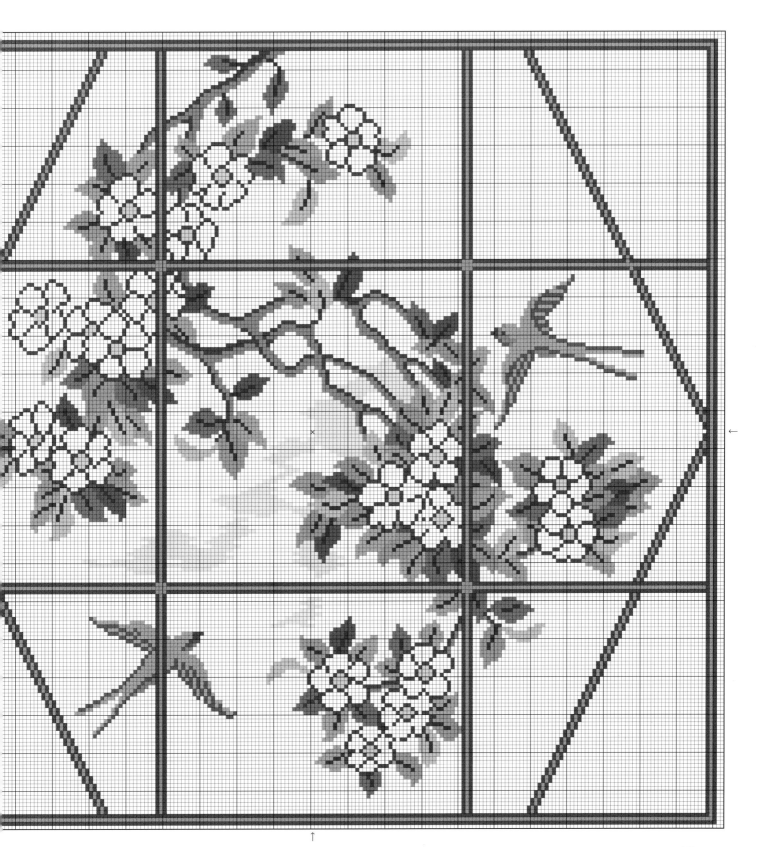

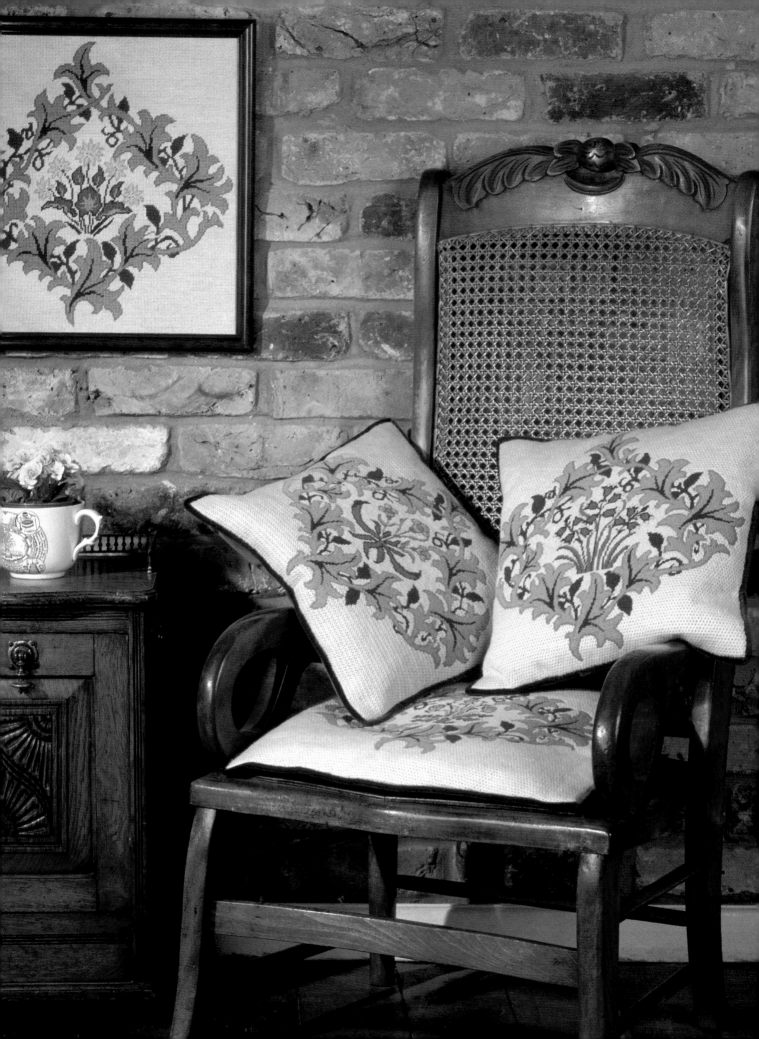

WILD FLOWERS

I first saw the *Celandine* wallpaper, originally designed for Morris & Co. by Henry Dearle, at Sanderson. The colours are flat – no shading – and the flowers simplistic. Here were four matching designs for a set of chair seats.

I began by drawing the wreath of leaves on canvas; the simplicity of the flowers dictated the choice of 14-count canvas. The wallpaper uses the same greens for the wreath and the leaves of the flowers, but I decided to add olive greens in the centre.

I was worried at first about the practicality of the cream background colour, so I chose three darker shades to tone with the flowers. If you look closely at the photographs showing the different background colours, you will notice that each embroiderer picked out a slightly different dividing line between the inner and outer background! In the end, I prefer the ivory shade. So the original colour wins.

Order of stitching

Refer to page 108 for how to prepare for stitching. All the *Wild Flowers* may be worked entirely in tent stitch using three threads of wool in the needle and for a chair seat or stool cover this is advisable as it is a hardwearing stitch.

A more decorative stitch may be used for the background. You may then require more threads in the needle and you will need to adjust the length of the stitches to fit around the design. Choose your own background colour to suit your furnishings; the colours shown in our photographs are listed overleaf. Five hanks will cover an area 41 x 41 cm (16 x 16 in). If you want to extend this area it is advisable to buy all the wool at the outset to ensure that it is all from the same dye lot.

There are seven colours common to all the designs with three extra for each different flower. Start each design in the centre and stitch the flowers first, then the wreath of leaves, the central background and finally the outer background.

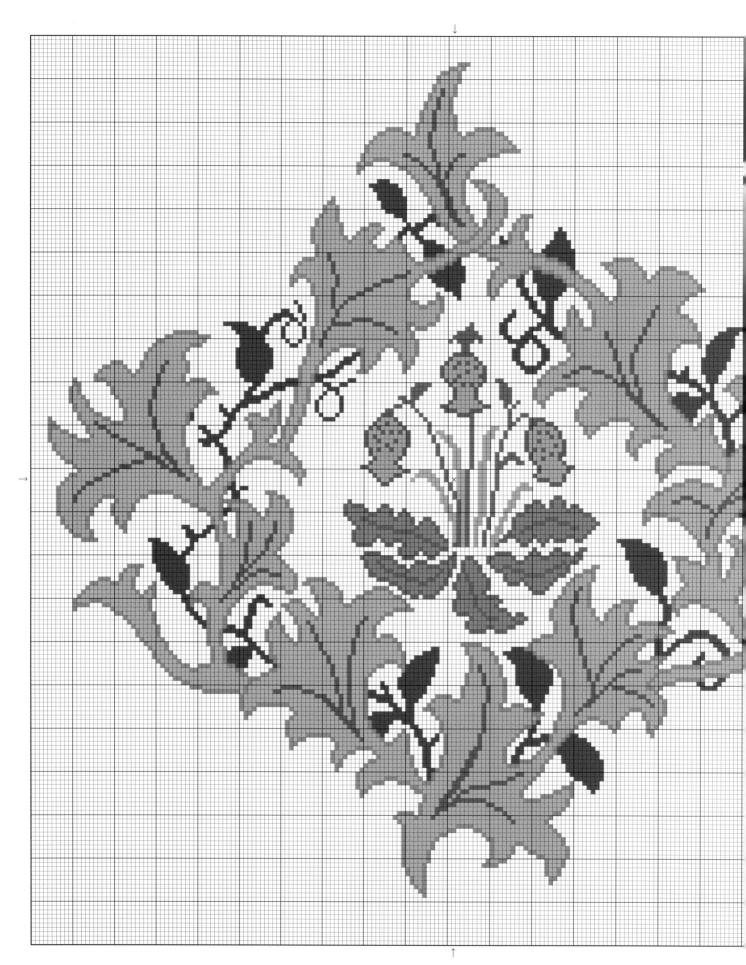

INSTRUCTIONS
Wild Flowers

Design size:
- 193 x 196 stitches
- 35 x 35.5 cm (13¾ x 14 in)

Materials:
- 14-count single canvas, 10 cm (4 in) larger in width and height than the intended stitched area, including the background
- Size 20 tapestry needle

Appleton crewel wool:

- ivory (882) – 1 hank
- light green (542) – 1 hank
- mid green (544) – 4 skeins
- dark grey-green (294) – 4 skeins
- dark green (547) – 4 skeins

- mid olive green (242) – 1 skein
- dark olive green (244) – 1 skein

Backgrounds
- Select a background suitable for your colourway, such as maroon (209), blue (321), ivory (882) or gold (694) – 5 hanks.

Harebell
- light olive green (241) – 1 skein
- light blue (561) – 1 skein
- darker blue (565) – 1 skein

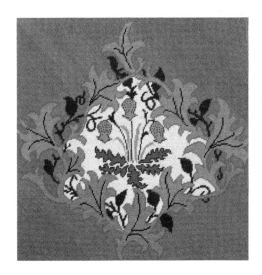

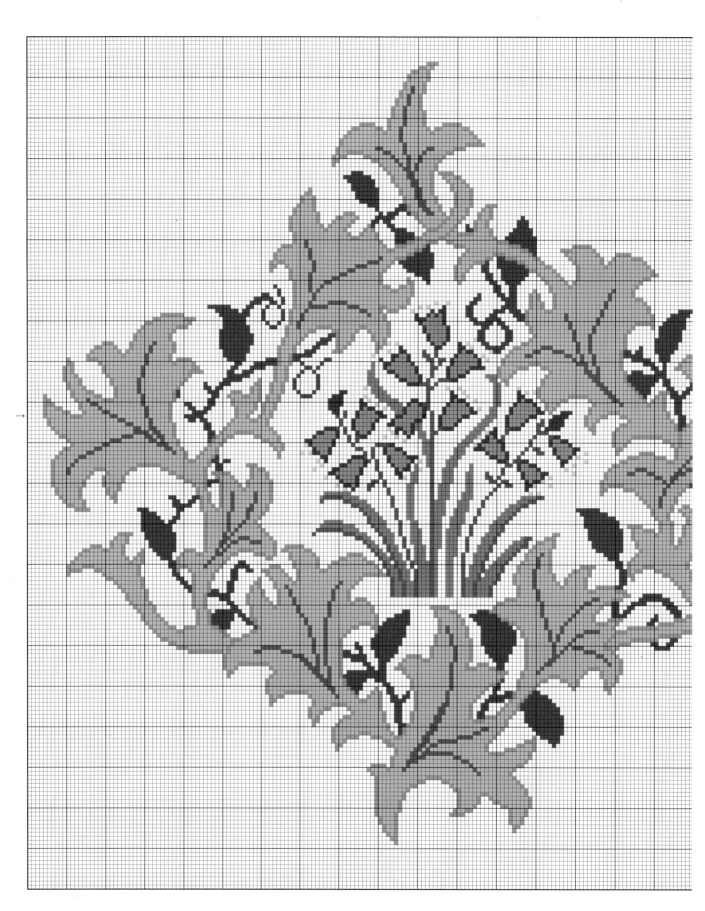

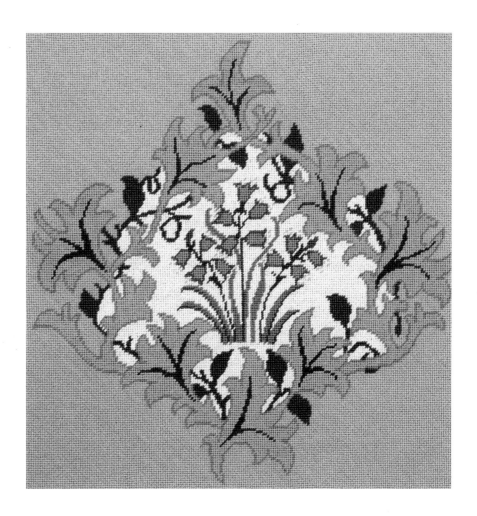

Bluebell

■ lighter blue (743) – 1 skein

■ darker blue (746) – 1 skein

□ yellow (474) – 1 skein

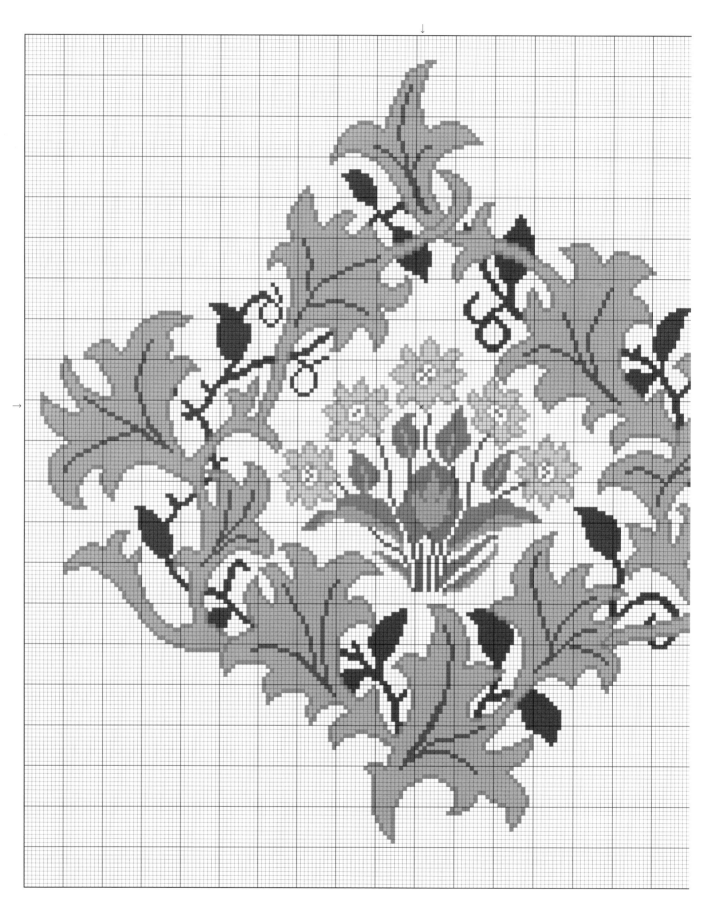

54

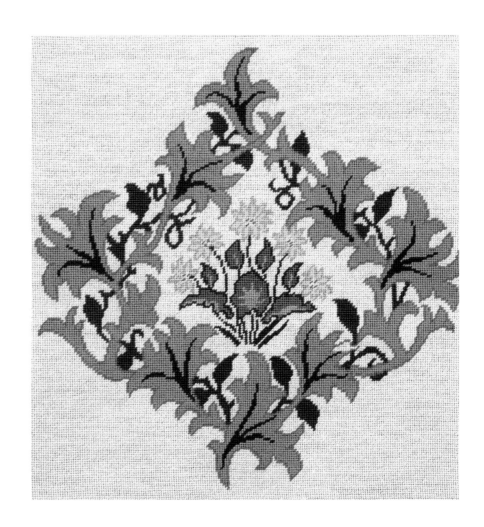

Celandine

light olive green (241) – 1 skein

light yellow (471) – 1 skein

darker yellow (473) – 1 skein

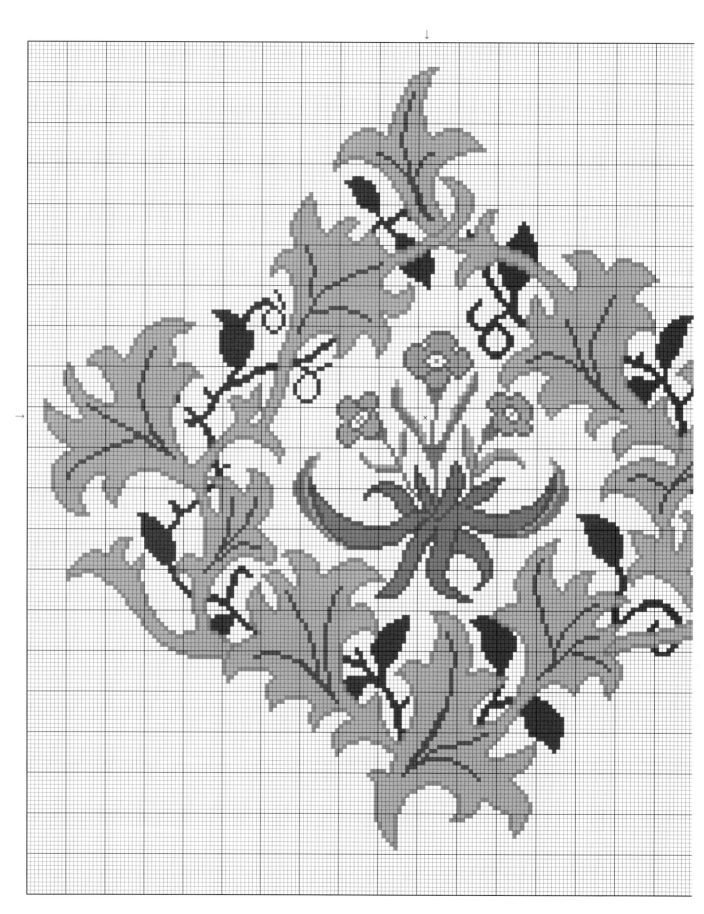

Primula

light olive green (241) – 1 skein

light pink (221) – 1 skein

deeper pink (223) – 1 skein

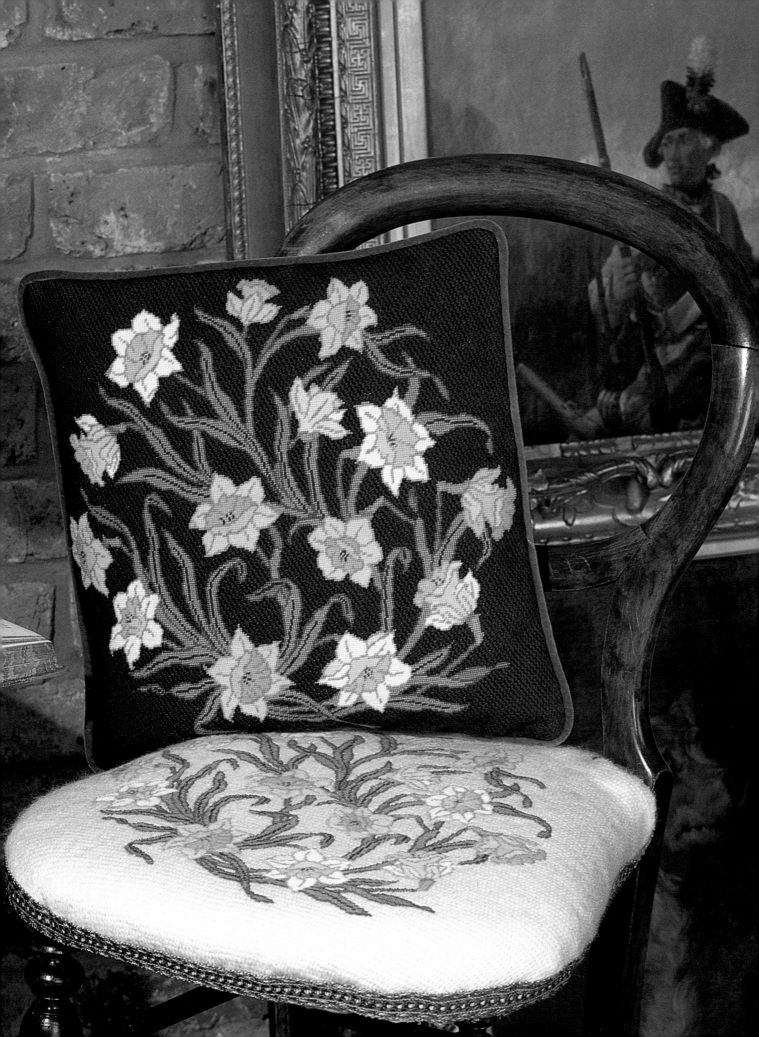

TULIPS AND DAFFODILS

A few years ago, I visited an exhibition of G. P. & J. Baker's fabrics at the Victoria and Albert Museum in London. The two brothers, sons of a merchant trading out of Turkey, were contemporaries of William Morris, and their company laid great emphasis on design. Their printed fabrics were strongly influenced by Turkish and Persian textiles, and their stylized floral patterns have remained immensely popular.

Two of their designs, both from the late 1890s, attracted me. *Lynham* has very stylized tulips growing from behind large, unrelated leaves, with a gorgeous swirling background. I knew I could not reproduce the background on canvas, and there was no small section of the design that made sense by itself – it needed to be seen as a large repeating pattern. Nevertheless, I still wanted to use the tulips.

Fortunately, I saw another design, *Garden of Tulips*, with more realistic tulip heads but strange wobbly leaves. I thought I could swirl them into a circle, and keep the head of the tulip from the first design (which was much easier to transfer to canvas) and the 'feel' of the other.

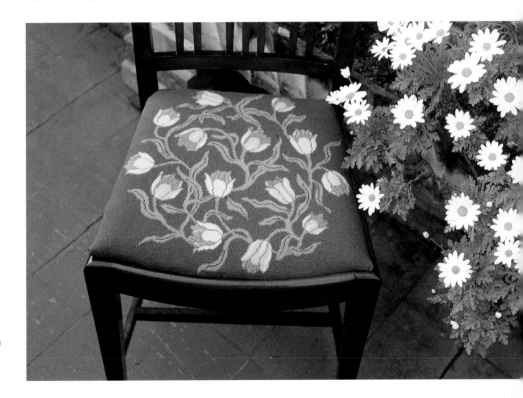

Left:
A host of golden daffodils! Choose between two different backgrounds – the stark contrast of the delicate flowers against the dark green, or the pale and pretty effect of the light green background.

Right:
This version of *Tulips* has a mid Prussian blue background (Appleton's 324). An alternative background colourway is shown overleaf.

I sketched the design, and my artist outlined it. To stitch all the heads in one set of colours would have been tedious, so I marked out two tulip head colours in two groups of yellows. When the design was finally stitched, and we could see it worked well, I was able to choose two sets of pinks as an alternative.

If neither of these fits in with your room setting, it would be a simple matter to create further colour schemes, based on natural tulip shades, for example a blend of whites and creams, or of different shades of red or purple.

The original of *Daffodils* was a black and white drawing I saw briefly at an exhibition in Hampstead, north London. Done in the early 1900s, it showed swirling daffodils. One normally thinks of daffodils as very straight and upright flowers – as, to start with, are tulips. I decided a companion to *Tulips* would be pretty, and I think they work very well together – I hope you agree.

Right:
The *Tulips* cushion on the windowsill at Kelmscott Manor. The modern Thai carving perfectly complements the style of the Arts and Crafts era.

Below:
This yellow *Tulips* colourway echoes the window so prettily. The stained glass was commissioned by William Morris when he first moved into Red House at Bexleyheath, and is found on the upper landing there.

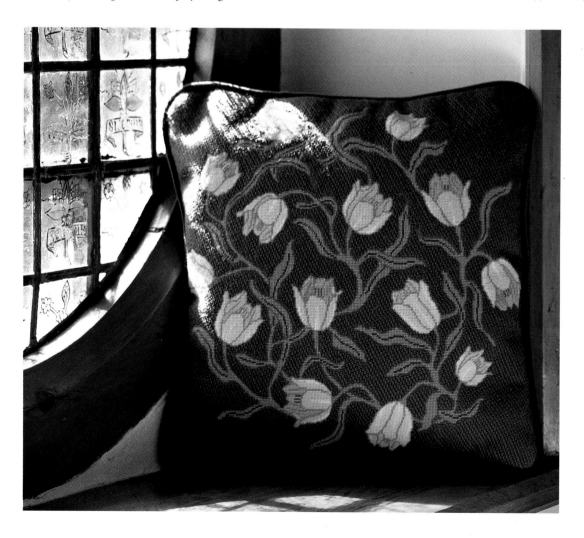

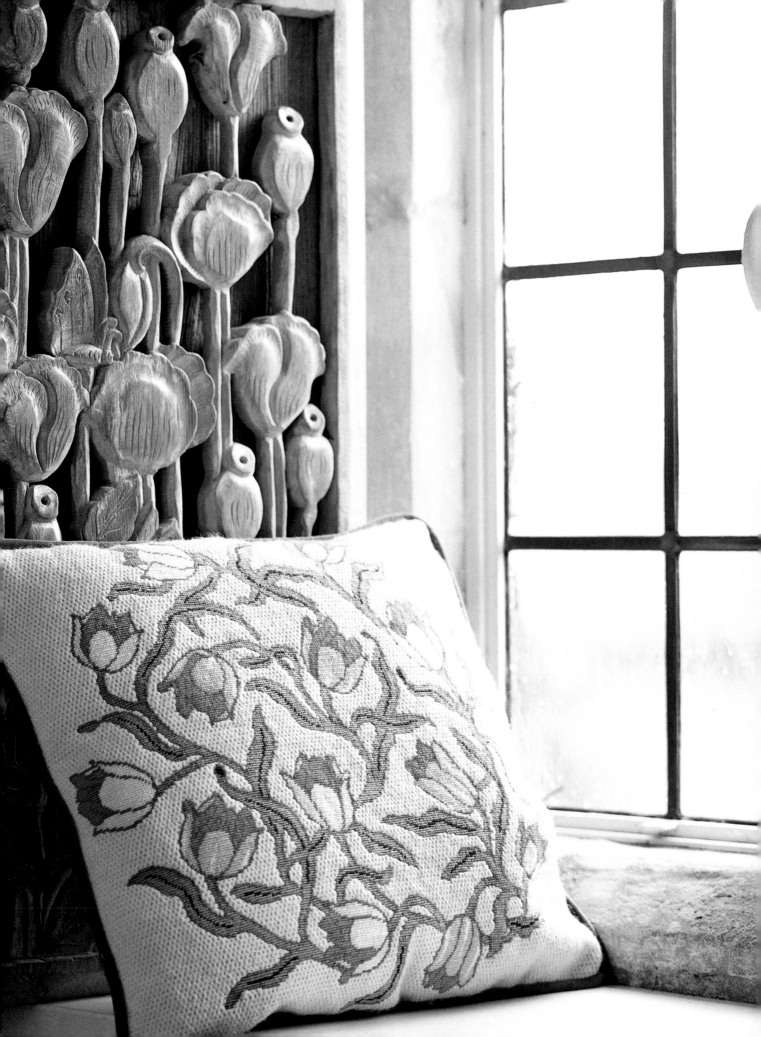

INSTRUCTIONS
Tulips

Order of stitching

Refer to page 108 for how to prepare for stitching.

Tulips may be worked entirely in tent stitch using two threads of wool in the needle and for a chair seat or stool cover this is advisable as it is a hardwearing stitch. For a more decorative finish the background may be stitched in cashmere or gobelin filling (see page 54 and 118); you may then require more threads in the needle and you will need to adjust the length of your stitches to fit around the design.

Three hanks of background wool are sufficient to extend the stitching to 41 x 41 cm (16 x 16 in). If you want to increase this area it is advisable to buy all the wool at the outset to ensure it is all from the same dye lot.

Count from the centre. Each square represents a stitch. Note that there are two 'sets' of tulips. Each flower is either stitched with light blue pink (751), mid blue pink (754) and dark blue pink (755) or pastel pink (877), mid brown pink (222) and dark brown pink (223).

Design size:
■ 253 x 264 stitches
■ 35.5 x 37 cm (14 x 14½ in)

Materials:
■ 18-count single canvas, 10 cm (4 in) larger in width and height than the intended stitched area, including the background
■ Size 22 tapestry needle

Appleton crewel wool:

light blue pink (751) – 1 skein white (991b) – 1 skein

mid blue pink (754) – 1 skein light green (352) – 1 hank

dark blue pink (755) – 1 skein mid green (354) – 4 skeins

pastel pink (877) – 2 skeins dark green (547) – 1 skein

mid brown pink (222) – 1 skein blue (324) or ivory (992) – 3 hanks

dark brown pink (223) – 1 skein

INSTRUCTIONS
Daffodils

Order of stitching

Follow the instructions for *Tulips* (see page 62). Note that there are two sets of flowers. The yellows are quite subtly shaded and it might be helpful to note the following:

For the darker flowers, the veins and outline of petals are worked in dark greeny yellow (842), the outlines of trumpets in orangey yellow (474) and the petals in clear bright yellow (551). The outside of the trumpets is worked in deep yellow (552), the inside in deepest yellow (553) and the underside of the petals in deepest yellow (553).

For the lighter flowers the veins and outline of petals and the outlines of the trumpets are worked in dark greeny yellow (842) and the petals in cream (871). The outside of the trumpets is worked in clear bright yellow (551), the inside in deep yellow (552) and the underside of the petals in creamy yellow (841).

Design size:
- 236 x 255 stitches
- 33 x 35.5 cm (13 x 14 in)

Materials:
- 18-count single canvas, 10 cm (4 in) larger in width and height than the intended stitched area, including the background
- Size 22 tapestry needle

Appleton crewel wool:

- cream (871) – 2 skeins
- creamy yellow (841) – 1 skein
- clear bright yellow (551) – 2 skeins
- deep yellow (552) – 1 skein
- deepest yellow (553) – 1 skein
- orangey yellow (474) – 1 skein
- dark greeny yellow (842) – 2 skeins

- lighter fawn (761) – 1 skein
- darker fawn (901) – 1 skein
- light yellowy green (543) – 1 skein
- light green (401) – 1 hank
- dark green (403) – 4 skeins
- deepest green (406) – 1 skein

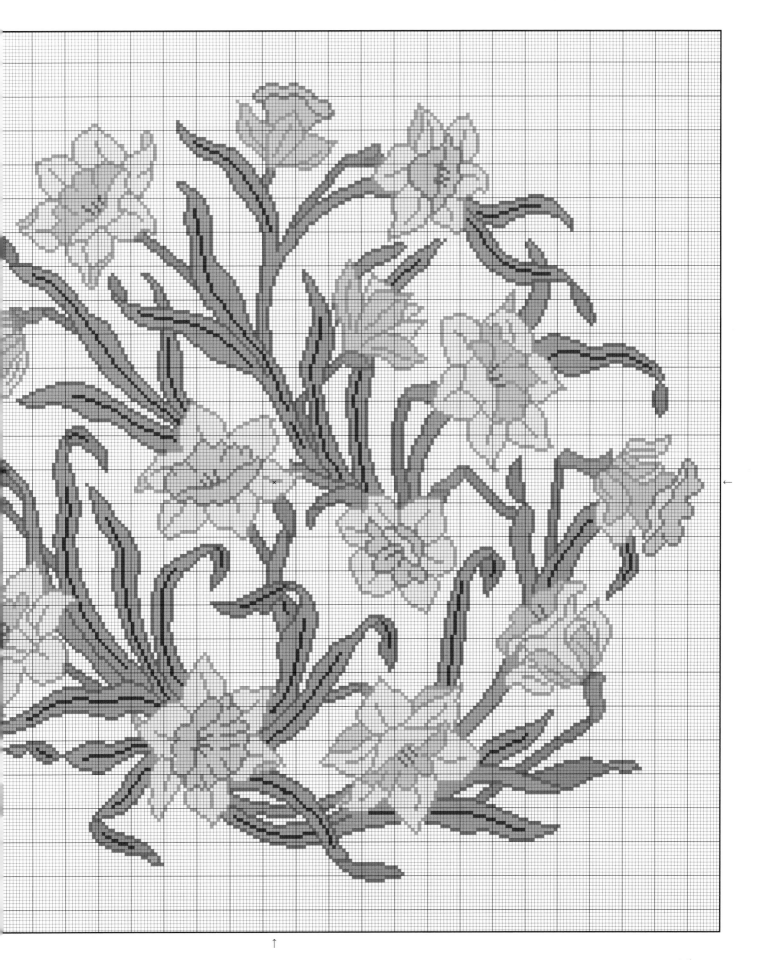

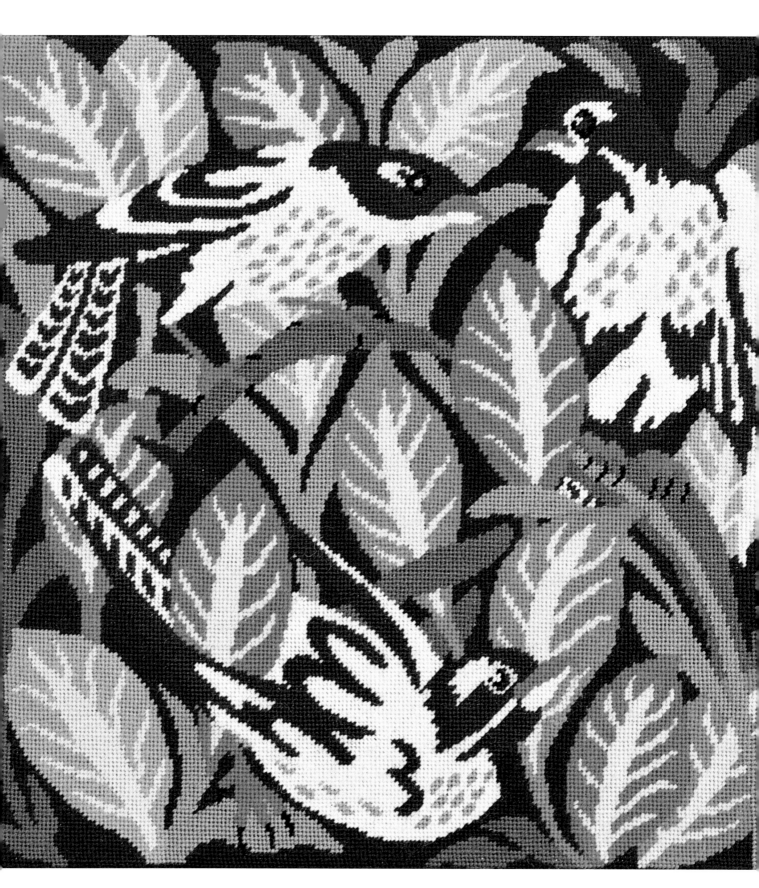

MAGPIES

The first time I saw this William De Morgan tile was in a black and white photograph. The way the birds are partially concealed behind the leaves was reminiscent of the Brangwyn panels that had entranced me as a child.

I failed to find the original tile, so I was not sure of De Morgan's colours. But, as he and William Morris worked together, it did not seem unreasonable to stick to Morris's shades (see *Magpies I,* left).

1 have now seen the original *Magpies* tile, and I am afraid the birds do not remotely resemble mine in colouring – I hope De Morgan will forgive me. I have since developed a new colour scheme, *Magpies II*, with green leaves and a light background, shown below. It illustrates the way in which a good design is capable of different interpretations.

The design echoes the original tile in filling the entire area, but for a cushion it might be better to extend the background area round the design or to frame it with a border, using some of the design colours.

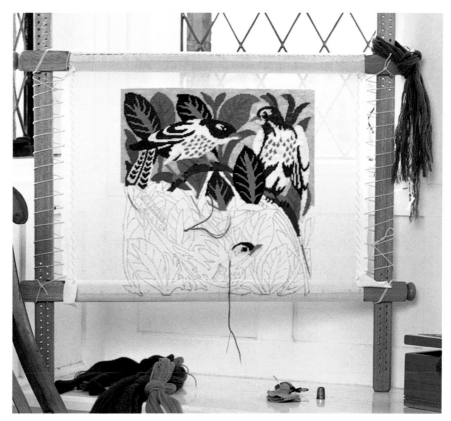

Left:
The first *Magpies* colour scheme, *Magpies I.*

Right:
My new colourway, *Magpies II*, shown half completed on a frame. I like to think that the partially worked embroidery and the outline of the design are reminiscent of William Morris's delicate working drawings. This alcove setting is in the first floor drawing room at Red House, Bexleyheath, where the light is ideal for embroidery.

INSTRUCTIONS
Magpies

Order of stitching

Refer to page 108 for how to prepare for stitching. The whole design is stitched in tent stitch using three threads in the needle. Start stitching from the centre in the large light pink leaf.

Two colourways are given below, *Magpies I* with pink leaves as shown in the pattern and *Magpis II*, worked in green leaves. The alternative green version is stitched simply by substituting the colours given in italics in the table below. Please note that, apart from the obvious colour changes, there is one significant difference in the versions of *Magpies*: in the pink *Magpies I* all the leaf veins are in the ivory 882 but in the green *Magpies II* the lighter green leaves which correspond to the yellow green leaves of *Magpies I* have light brown veins 764, while the darker green leaves have veins in 251a.

Should you decide you would like a border of background colour or even stripes of some design colours, make allowances at the outset for extra wool to ensure it is all from the same dye lot.

Appleton crewel wool:

Magpies I (pink leaves)
and *Magpies II (green leaves)*

■ lighter pink (204) – 1 hank
 or darker green (255)

■ darker pink (205) – 1 hank
 or darkest green (256)

■ light yellow green (331) – 4
 skeins *or mid green (251)*

☐ ivory (882) – 1 hank
 or pale green (251a)

■ light green (352) – 4 skeins
 or light brown (764) – 1 hank

■ dark honey (695) – 1 skein
 or yellow (474)

■ blue-green (642) – 4 skeins
 or dark brown (766)

■ light grey (151) – 1 skein

■ dark grey (976) – 1 hank
 or dark grey (965)

■ black (993) – 1 skein

☐ white (991) – 1 hank

■ dark blue (926) – 1 hank
 or ivory (882)

Design size:
■ 202 x 202 stitches
■ 36 x 36 cm (14¼ x 14¼ in)

Materials:
■ 14-count single canvas,
 51 x 51 cm (20 x 20 in)
■ Size 20 tapestry needle

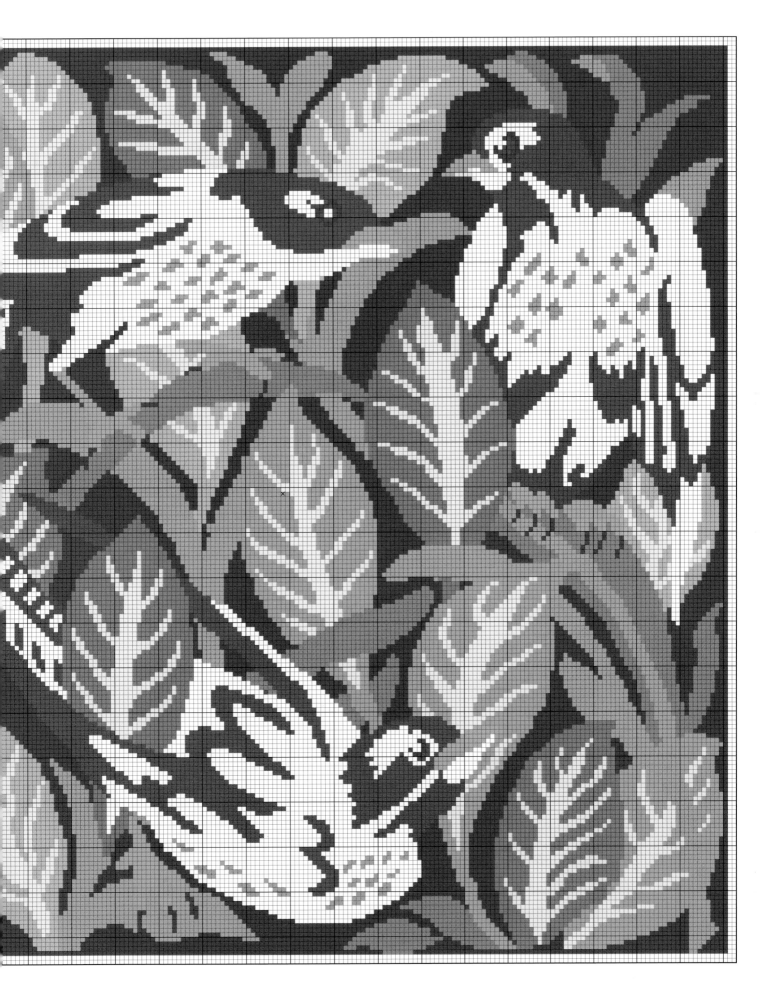

HOLLAND PARK

William Morris's name for this handsome design was *Carbrook*, a hand-tufted carpet produced by 'the Firm' more than once. Alexander Ionides commissioned the carpet from Morris & Co. for the Antiquity Room in his house at No. 1, Holland Park, West London, in 1883, and it is now in the Victoria and Albert Museum in London. I used to refer to the design as *Holland Park* when I was working on it and the name stuck.

Before seeing the original Ionides carpet, I had been working on a brown colour scheme as I had already produced several designs in blue. I had only seen a black and white photograph of the original, so it was interesting to find that the colours I had chosen were very similar, except the original has a blue background. It is as well I had not seen it previously as the sheer size would have discouraged me from proceeding.

Holland Park, or *Carbrook*, works well on the finer 8-count canvas, making a rug 122 x 69 cm (48 x 27 in). It looks equally elegant if the design colours are modified to suit a blue or light grey background. You could also isolate part of the central panel to make a carpet bag, again working on 8-count canvas and using four threads of Appleton tapestry wool.

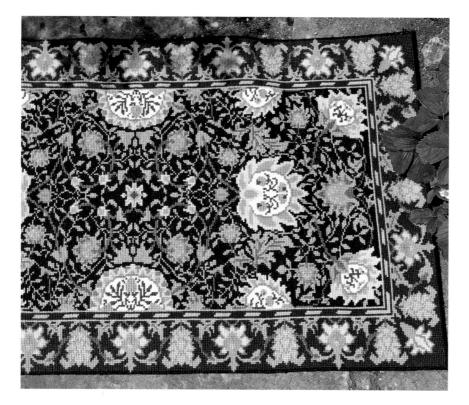

Left
A blue version of the Holland Park design.

Right:
Set in William Morris' own bedroom at Kelmscott Manor, the Holland Park rug in a brown colourway sits well on top of Daisy or Grass carpet designed by Morris and woven by Wilton in the 1870s. Jane Morris' 'Si je puis' embroidery on the bedspread echoes her husbands 'If I can' on his own embroidered wall hanging in the Green Room.

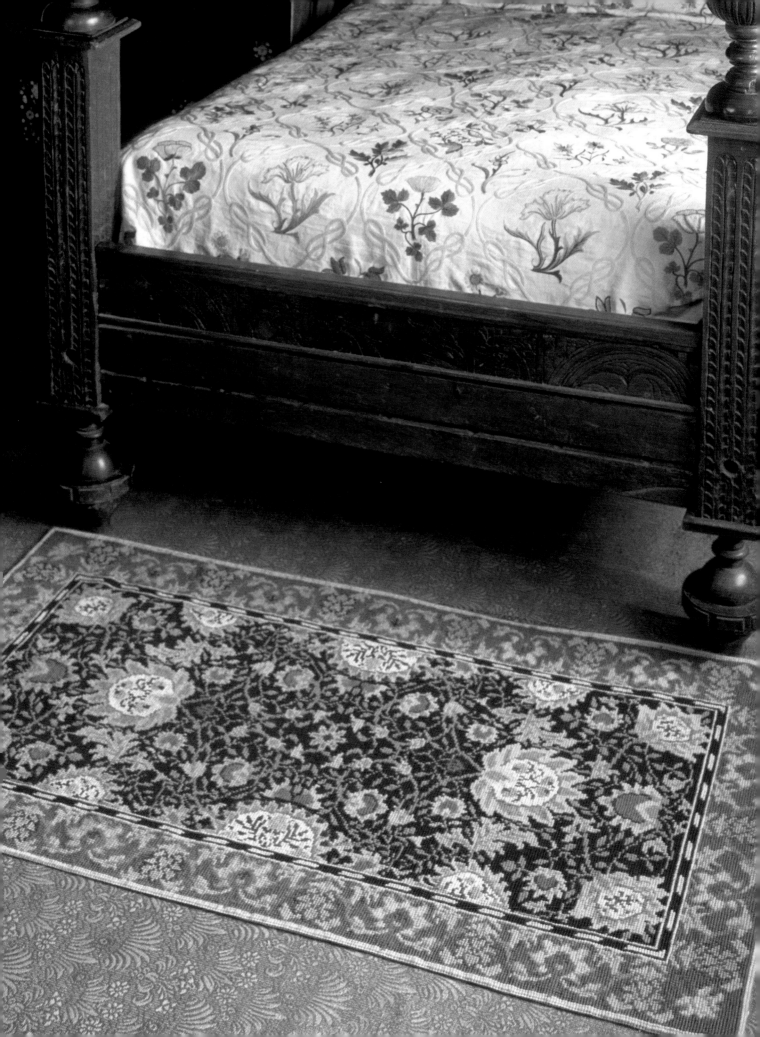

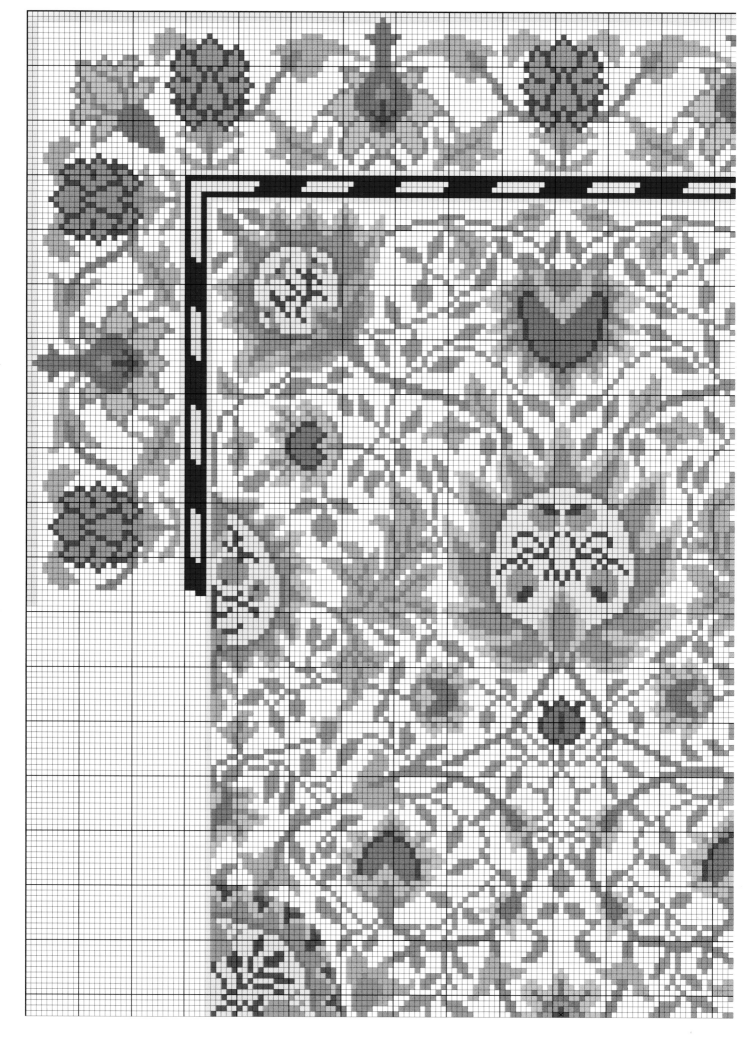

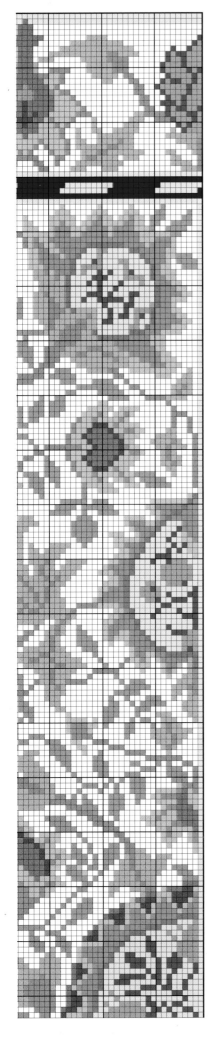

INSTRUCTIONS
Holland Park Rug

Order of stitching

Mark the wools with their identifying numbers when they are purchased to avoid confusion later. Refer to page 108 for how to prepare for stitching. Find the centre of the canvas by folding in half both ways. Baste along these folds with brightly coloured sewing thread to quarter the design. This makes it easier for you to count from the chart.

This is a large canvas and if you are not using a frame you might find it helpful to roll the canvas at both ends, leaving flat just the part you are to work on. The rolls can be secured out of your way with a large safety pin or a few large stitches.

The whole design is worked in cross stitch using two threads of wool in the needle. See page 118. Start with the small central flower at the base of the chart. Each square on the chart represents one cross stitch. Complete all the design in the central panel before filling in the background then stitch the border in the same order. Pay special attention to the borders – the distance between the motifs in the short border is different from that on the longer sides. Turn the chart around to work the second half.

Design size:
- 369 x 203 stitches
- 155 x 86 cm (61 x 34 in)

Materials:
- 6-count Zweigart rug canvas 180 x 100 cm (71 x 40 in)
- Size 16 tapestry needle

Appleton tapestry wool:
- browny maroon (126) – 1½ hanks
- dark browny pink (124) – 4 hanks
- mid pink (204) – 4 hanks
- light pink (121) – 7 hanks
- 'dirty' ivory (691) – 7 hanks
- drab green (333) – 5 hanks
- light green (353) – 8 hanks

- darker green (354) – 4 hanks
- lighter blue (641) – 3 hanks
- darker blue (156) – 3 hanks
- deep red maroon (209) – 2½ hanks
- grey (973) – 10 hanks, for the background of the border and dark grey (976) — 13 hanks, for the background of the main pattern

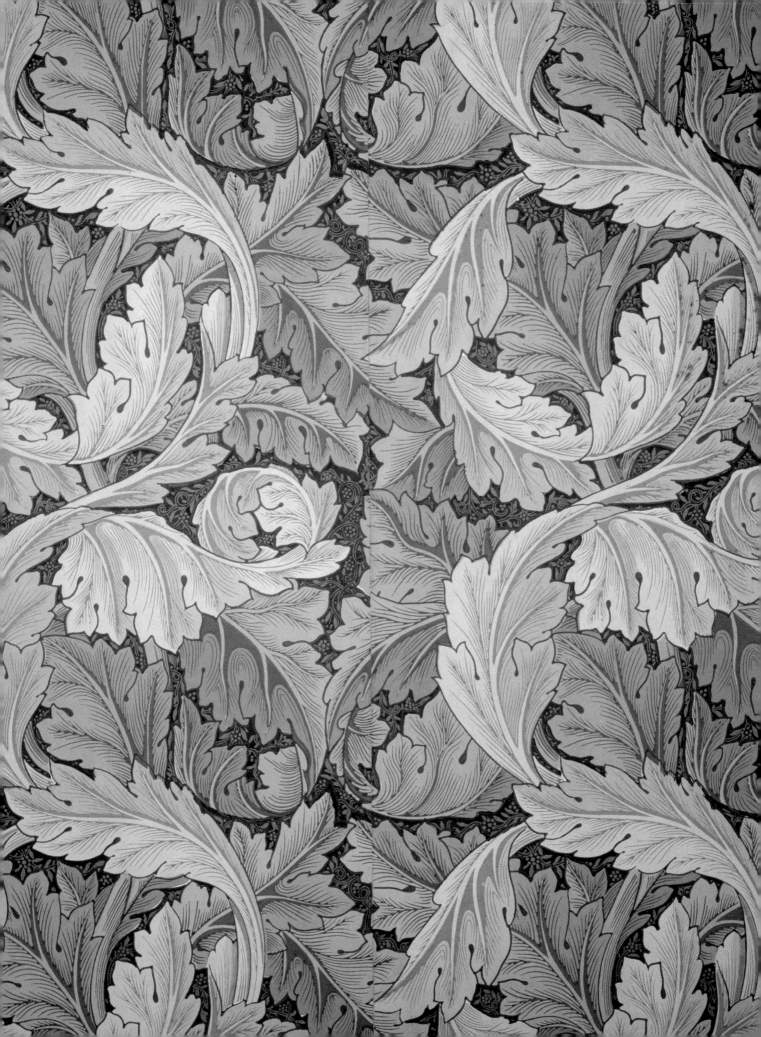

ACANTHUS

This intriguing design was inspired by a wall hanging designed by William Morris, which I saw in an exhibition of Arts and Crafts textiles held at the Victoria and Albert Museum in London. Morris had several versions worked in different techniques and colours, but it was the silk embroidered hanging (left) that attracted me.

When I started work on it, it did seem the most impractical design I had ever embarked on. I had to use the finer of the two rug canvases to its full width to fit the design in. I have tried to retain the original colours as well as the design as far as possible. As a commercial kit (my original intention) it seemed a no-hoper, but I just loved it and it is still my favourite design. The shades of pink and green are so close that charting them was a nightmare; I wondered if they were really necessary, but to simplify Morris's original was unthinkable.

The background is a blend of two shades to try to reproduce the colour of the silk as closely as possible. In the rug in the photograph below, the border background was worked with three strands of one shade and one of the other, and the centre background in two strands of each shade.

The blue background may not be right for your setting. Almost any dark shade would look effective; I long to see *Acanthus* against a charcoal background.

Left:
Acanthus wallpaper designed by Morris in around 1875. It appears in the Acanthus bedroom at Wightwick Manor.

Right:
Acanthus used in a traditional way – as a table covering at Kelmscott Manor.

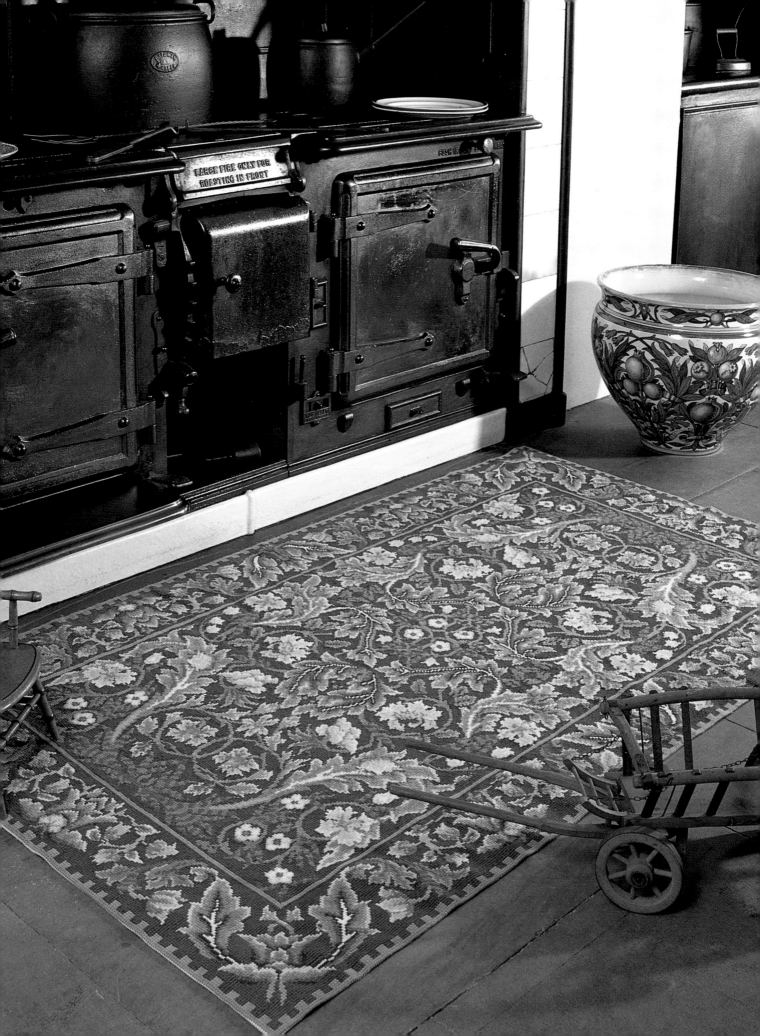

INSTRUCTIONS
Acanthus

Order of stitching

As this design uses several very close shades it would be prudent to mark the wools with their identifying numbers when they are purchased to avoid confusion later.

Find the centre of the canvas by folding in half both ways. Baste along these folds with brightly coloured sewing thread to quarter the design. Ths makes it easier for you to count from the chart.

If you have decided to use a frame see pages 112–113. This is a large canvas and if you are not using a frame you might find it helpful to roll the canvas at both ends, leaving just the part you are to work on. The rolls can be secured out of your way with a large safety pin (a nappy pin is ideal) or a few large stitches.

The whole design is worked in cross stitch using four threads of wool in the needle. see page 118.

Start by counting from the centre of the chart to the biscuit-coloured stems and stitch those first. Each square on the chart represents one cross stitch. Work the design first. See the chart on pages 80–81.

For the background a blend of the two blues is used, two of each shade. Alternatively you can use three strands of one and one of the other for the centre panel and reverse the blend for the border background.

Left:
An *Acanthus* rug in front ot the original kitchen range at Standen. The charming toys, chair and Suffolk cart have recently been found in the attic and belonged to the Beale family. The jardiniere went so well with the rug that I couldn't resist putting it into the photograph.

Design size:
- 503 x 289 stitches
- 162.5 x 98 cm (64 x 38½ in)

Materials
- 7- or 8-count Zweigart rug canvas, 190 x 122 cm (75 x 48 in)
- Size 16 tapestry needle

Appleton crewel wool:

- ☐ cream (881) – 2 hanks
- ☐ pale flesh pink (706) – 2½ hanks
- ☐ deeper flesh pink (708) – 1 hank
- ☐ coral (204) – 1 hank
- ☐ lightest flesh pink (703) – 1½ hank
- ☐ light dirty pink (202) – 2 hanks
- ☐ dark dirty pink (122) – 1 hank

- ☐ creamy green (873) – 2 hanks
- ☐ brown (762) – 4½ hanks
- ☐ pale yellowy green (331) – 2½ hanks
- ☐ light olive (241) – 5½ hanks
- ☐ mid olive (242) – 4 hanks
- ☐ dark olive (244) – ½ hank
- ☐ pale mint green (874) – 5½ hanks

- ☐ pale green (352) – 6½ hanks
- ☐ deeper green (401) – 6½ hanks
- ☐ mid grey green (293) – 4½ hanks
- ☐ darkest green (294) – 2½ hanks
- ☐ yellow (842) – 5 hanks
- ☐ 2 threads (565) 2 threads (324) – 15 hanks of each

As the shades are so subtle, it might be helpful to note the following:

The large darker green leaves have a central vein of creamy green (873) outlined by the darkest green. The tips of these leaves are stitched in pale mint green (874) and then shaded gently towards the veins using, in turn, pale green (352), deeper green (401) and mid grey green (293).

The lighter large green leaves also have the very pale creamy green (873) in the centre of the veins but now surrounded by brown (762). The shading from the outside inwards is the same: pale mint green (874), pale green (352), deeper green (401) and mid grey green (293).

There are two sets of pinks: the border flowers and the three in the middle of each end of the central panel are made using lightest flesh pink (703) as the lightest, then light dirty pink (202) with dark dirty pink (122) for the dark shading with deeper green (401) green parts.

The large flowers in the centre panel are stitched with cream (881) as the palest shade with pale flesh pink (706) next, then deeper flesh pink (708) and coral (204) used for the darkest shaded areas. The small flowers in this area are made with cream (881) and pale flesh pink (706).

To complete the rug see page 121.

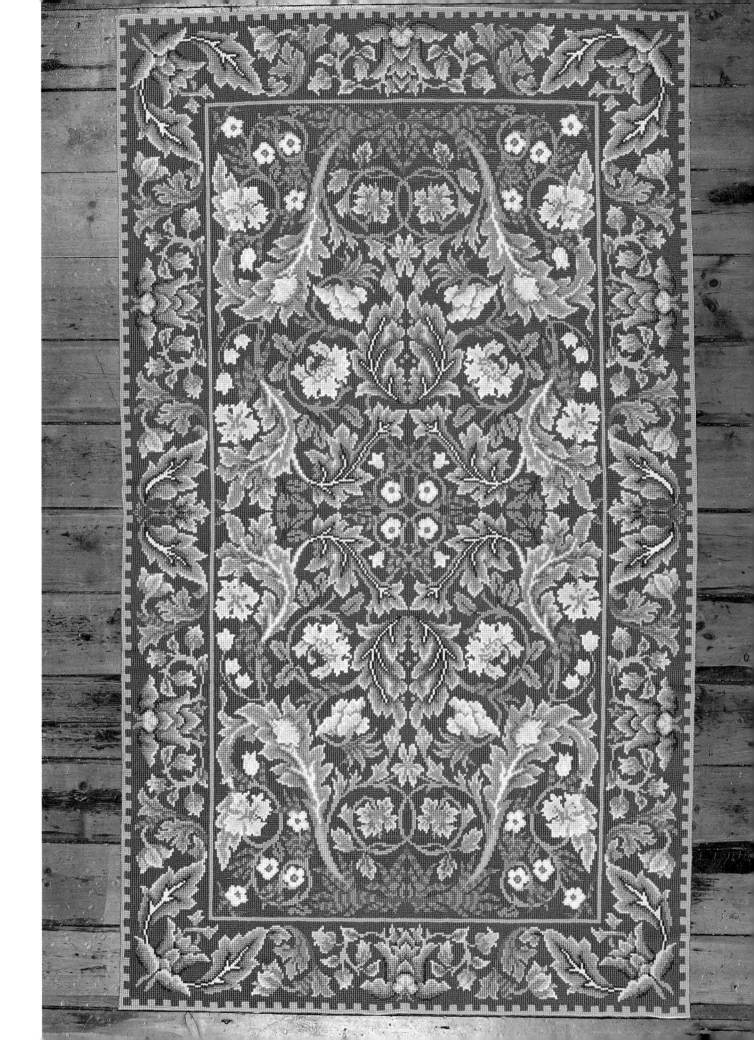

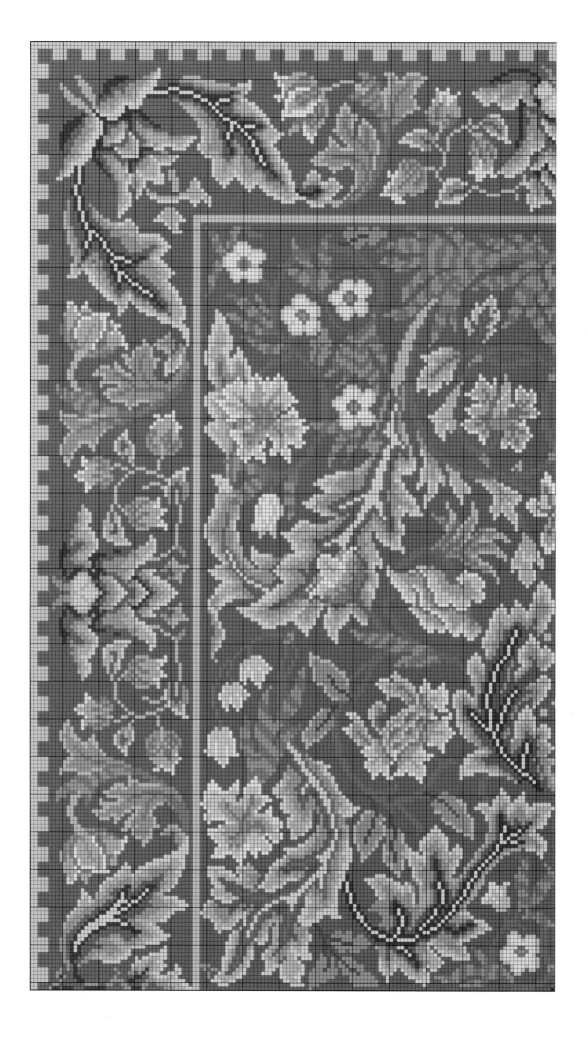

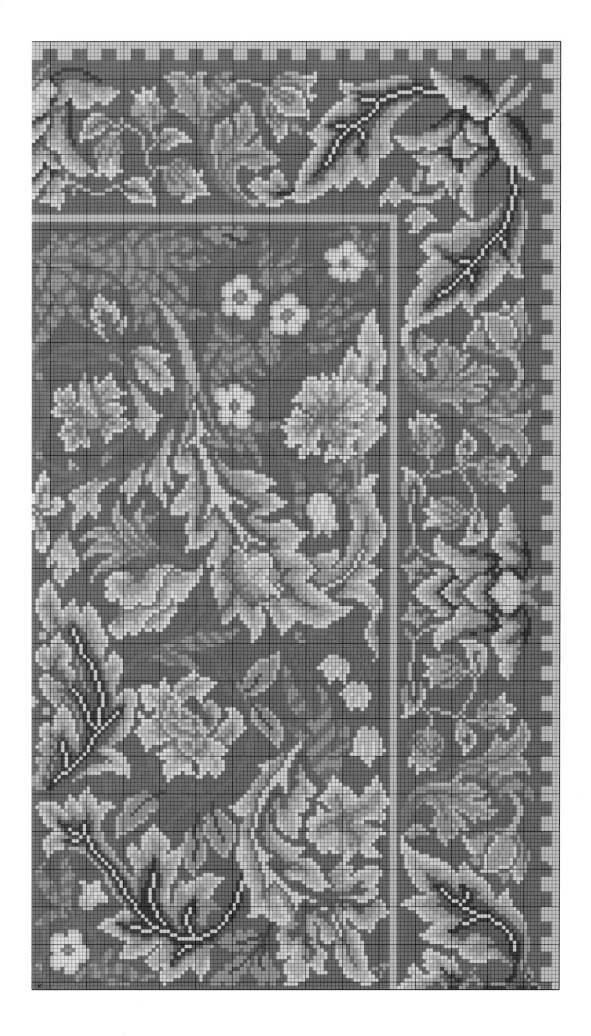

HAMMERSMITH

Hammersmith as a title for this design is a little confusing, as William Morris used the name for all his hand-tufted carpets. He was attempting at the time to improve the general standard of design in manufactured carpets in Victorian England, and the name Hammersmith was used to distinguish between the two.

This design was produced on a loom at Merton Abbey when Morris was living at Kelmscott House (named after Kelmscott Manor) on the river Thames in Hammersmith, west London. I love the strong simplicity and the traditional colouring. Morris was a great collector of Oriental rugs, which he used as wall hangings. The Hammersmith or hand-tufted rugs were individually designed and would have been very costly. They are all works of art.

It was comparatively easy to interpret the main design in cross stitch on coarse canvas. I was forced to omit some fine tracery, which would not curve enough and looked too heavy on the canvas. Otherwise the needlepoint looks much like the original. I do, however, keep promising myself that I will knot the fringe as beautifully as that on the Hammersmith which inspired me to attempt my first 'carpet'.

Right:
The *Hammersmith* design works really well in the simplicity of the beamed attic at Kelmscott Manor. The *Rose Tile* cushion (see page 100), worked in a matching colourway, sits on a chair designed by Rossetti. Behind it hangs a lovely silk embroidery of rose trees.

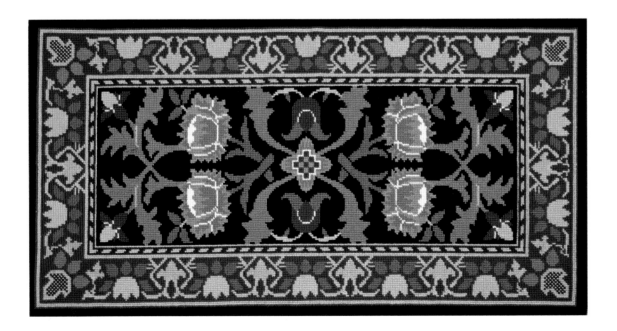

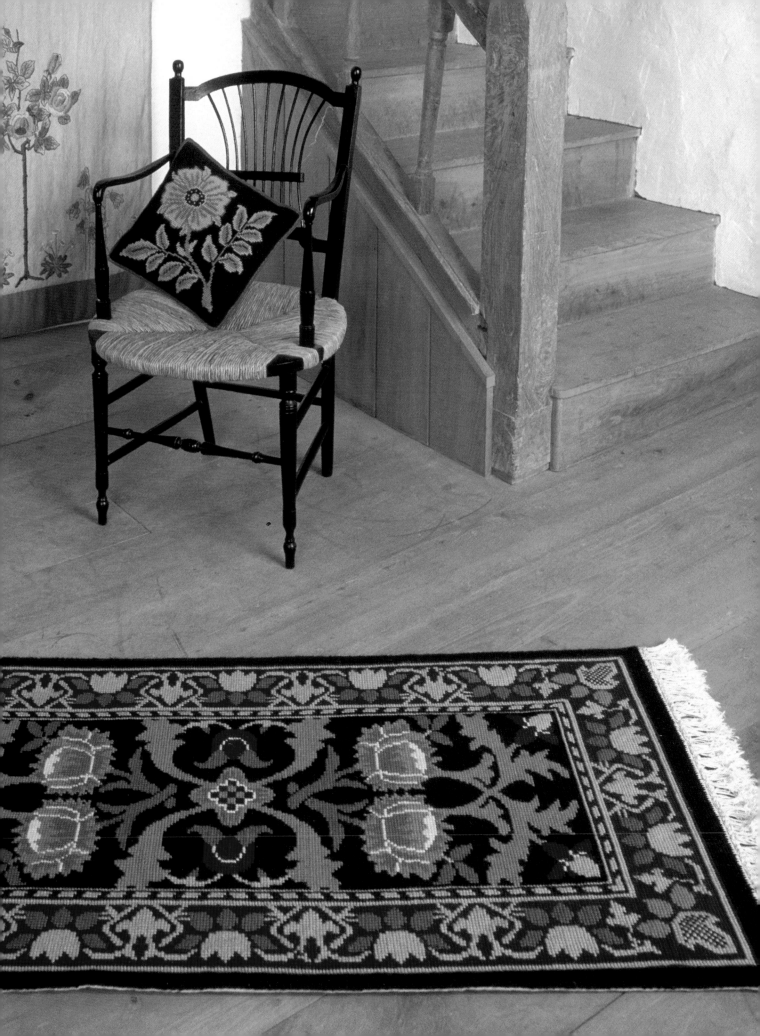

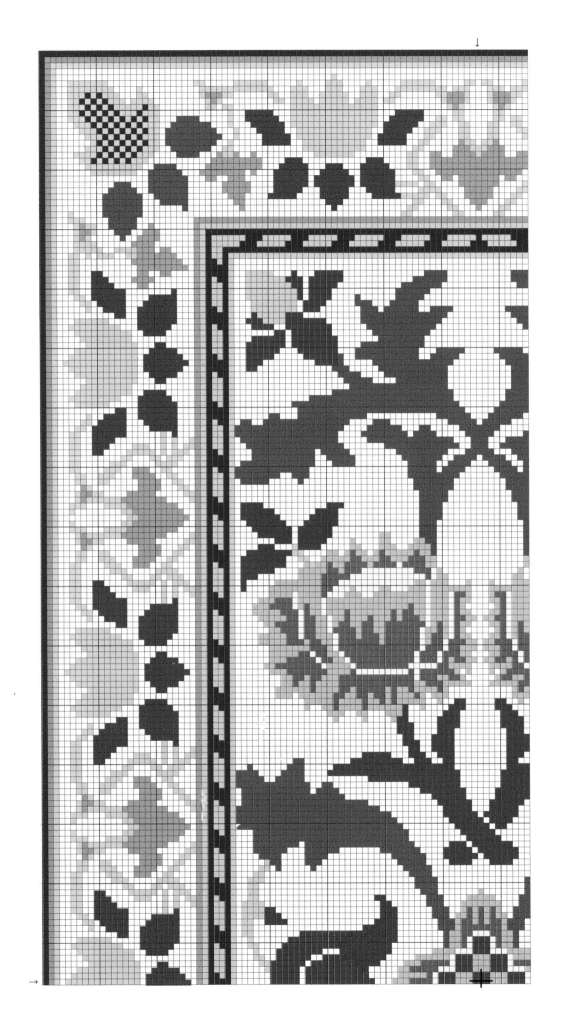

INSTRUCTIONS
Hammersmith

Design size:
- 325 x 165 stitches
- 137 x 70 cm (54 x 27½ in)

Materials:
- 6-count Zweigart rug canvas 160 x 100 cm (63 x 40 in)
- Size 16 tapestry needle

Appleton tapestry wool:

- light pink (204) – 2 hanks
- mid pink (206) – 1½ hanks
- dark red (227) – 10 hanks
- olive green (342) – 4½ hanks
- grey green (293) – 4 hanks
- light blue (521) – 3½ hanks
- beige (984) – 9 hanks
- cream (881) – ½ hank
- dark blue (929) —13 hanks
- very dark maroon (128) – 2 hanks

Order of stitching

Find the centre of the canvas by folding in half both ways. Draw with a hard pencil or baste along these folds with brightly coloured sewing thread to quarter the design and assist in counting the stitches of this symmetrical design. These lines will correspond with the centre marks on the chart.

If you have decided to use a frame see pages 112–113. This is a large canvas and if you are not using a frame you might find it helpful to roll the canvas at both ends, leaving just the part you are to work on; the rolls can be secured out of your way with a large safety pin (a nappy pin is ideal) or a few large stitches.

The whole design is worked in cross stitch using two threads of wool in the needle. See page 118.

Find the centre and start with the nine central stitches in dark red (227). Work the design before the background. The background colours have not been printed on the chart. The central background colour is the dark blue (929) and the border background is the dark red (227).

At the very outside of the rug, beyond the three coloured stripes, stitch six rows of dark blue (929) all around the rug.

As this canvas is 100 cm (40 in) wide there is room on the canvas should you wish to extend the rug by stitching a wider border. If you decide to do this, allow an additional two hanks for every three rows of stitching. Remember to leave enough unworked canvas for finishing.

When half the design is complete, turn the chart upside down and stitch the second half. Suggestions on how to complete and back your rug are given on page 121–123.

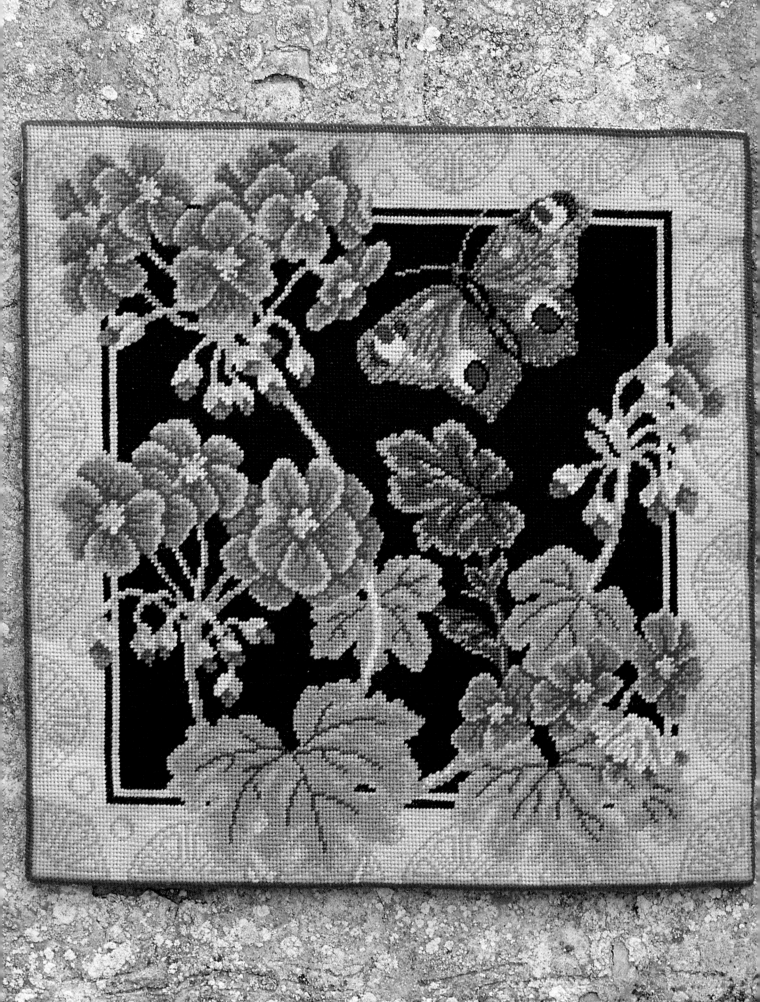

JACKFIELD GERANIUM

In the course of my research into Morris's contemporary, William De Morgan, I came across some beautiful pictorial tiles made by Maw & Co. around 1880. Each has a wide border, with the design overlapping them to give the same sort of three-dimensional effect that I admire in William Morris' *Trellis* (page 40). These strong yet simple designs were ideal for making up into square cushions.

George Maw was one of the first people to use six or more colours in tile production. His experiments with techniques and glazes were so successful that in 1883 he set up a factory at Jackfield in Ironbridge, Shropshire, which in its heyday was producing over 20,000,000 tiles and other ceramics a year, across a range of some 9,000 lines. Among the talented freelance designers that he employed were Walter Crane and Lewis Day, both founder members of the Arts and Crafts Exhibition Society.

The factory has gone, but many of its original products are displayed in a museum on the old site in the Ironbridge Gorge, an area that has been brilliantly restored as a vast open-air museum demonstrating the way that iron, porcelain and other products were made a hundred years ago. It is well worth a visit – you will need at least a day to see it all.

Left:
Jackfield Geranium was taken from a George Maw tile design.

Right:
You can achieve subtle effects by creatively blending colours in your needle. For details of the wools used see the diagram on page 88.

INSTRUCTIONS
Geranium Tile

Order of stitching

Refer to page 108 for how to prepare for stitching.

The whole design is stitched in tent stitch using three threads in the needle. Find the centre of the canvas and chart then count the squares to the dark leaf and work this first. Please note that, in this dark leaf only, the veins are stitched in black.

Complete the rest of the design first, including the border.

The butterfly has been stitched using many blends of different colours, as you can see in the close up photograph on page 87. The position of the blended areas is shown in the chart and a more detailed diagram indicating the exact threads used is provided below. This is an opportunity to experiment with blends of yarns. Still use the three threads in the needle, of course, but in certain areas vary the quantities of colours used to give your own butterfly a unique and personal beauty. No two will then be exactly alike. This is part of the charm of needlepoint and great fun.

When the design is complete, the backgrounds may be stitched: the central area is to be stitched in black and the border (which also has been left uncoloured on the chart) in light yellow. Note the row of dark coral all around the finished piece.

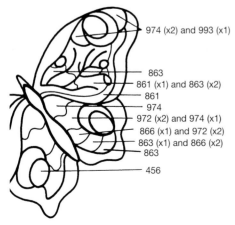

974 (x2) and 993 (x1)
863
861 (x1) and 863 (x2)
861
974
972 (x2) and 974 (x1)
866 (x1) and 972 (x2)
863 (x1) and 866 (x2)
863
456

Design size:
- 201 x 201 stitches
- 37 x 37 cm (14½ x 14½ in)

Materials:
- 14-count single canvas, 50 x 50 cm (20 x 20 in)
- Size 20 tapestry needle

Appleton crewel wool:

- dark coral (866) – 4 skeins
- mid coral (863) – 1 hank
- pale coral (861) – 4 skeins
- pale mint green (874) – 1 skein
- bright green (253) – 4 skeins
- pale yellow green (251a) – 4 skeins
- light grey green (352) – 4 skeins
- dark green (356) – 1 skein
- black (993) – 1 hank + 4 skeins
- light grey (972) – 1 skein
- dark grey (974) – 1 skein
- mauve (456) – 1 skein
- dark yellow (474) – 1 hank
- light yellow (471) – 2 hanks

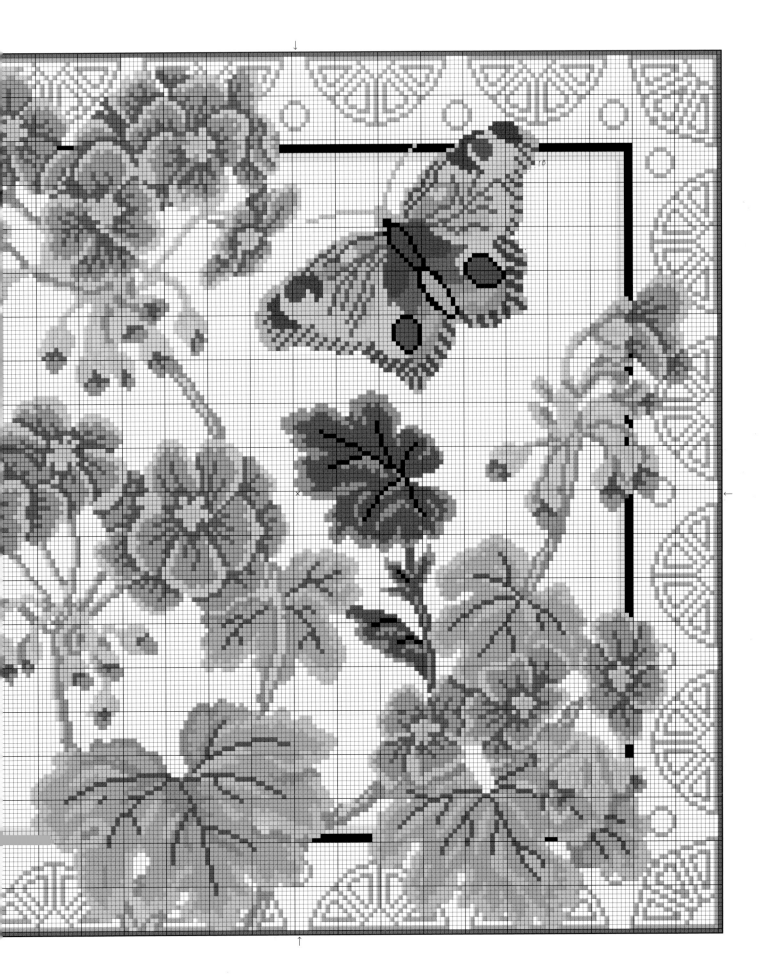

COUNTRY FLOWERS

An exhibition at the Victoria and Albert Museum, London, of fabrics produced by the firm of G.P. and J.Baker inspired this design, and also *Tulips* (page 58).

It is a very traditional pattern, each section containing a flower. The ogival and lozenge shapes run into each other and the overlapping outlines are filled with stylized leaves. I liked the fact that the designs could be neatly finished, and *Country Flowers, Spring* gave me the opportunity to use some wonderfully intertwined daffodils I had seen elsewhere.

The *Country Flowers, Spring* design illustrated features crocuses at the top and bottom, but I have also included an optional snowdrop pattern, which you might like to use to replace either the yellow or purple crocuses.

Country Flowers, Summer followed on naturally from *Country Flowers, Spring* and has proved to be more popular, perhaps because of the emphatic poppies. In this case, you could use the extra daisy pattern to add variety.

A lot can be done with this design. My own preference, where *Country Flowers, Spring* is concerned, is for the dark background, which makes the flowers stand out. If you are stitching both designs to make a pair, you could strengthen the colours of *Spring* to match *Summer*. You could also emphasize the design by stitching a thicker line of green round the outside to frame it.

The small flowers are useful for a chair seat with a wide front, as they can be added at the bottom only. For a larger stool, you could add a whole section so that there are four tall flowers. This is easily done by extending the lines around the daffodil or poppy to match those that enclose the iris or cornflower. If you need a very long design (perhaps for a fender stool), you could repeat the iris. And if the design is too deep for a chair, then leave out the crocuses or buttercups. There is endless scope for variations – you could even experiment with other flowers.

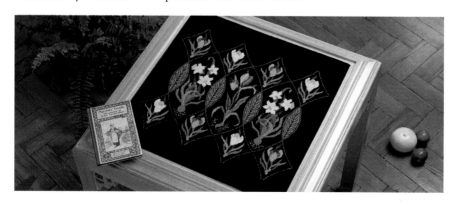

Left:
An extended version of *Spring*, worked with a dark background to give the design a completely different feel.

Right:
I've produced two *Country Flowers* designs: *Spring* (left) and *Summer* (right). Made up as cushions, they are shown on a tree seat in the front garden at Red House, Bexleyheath.

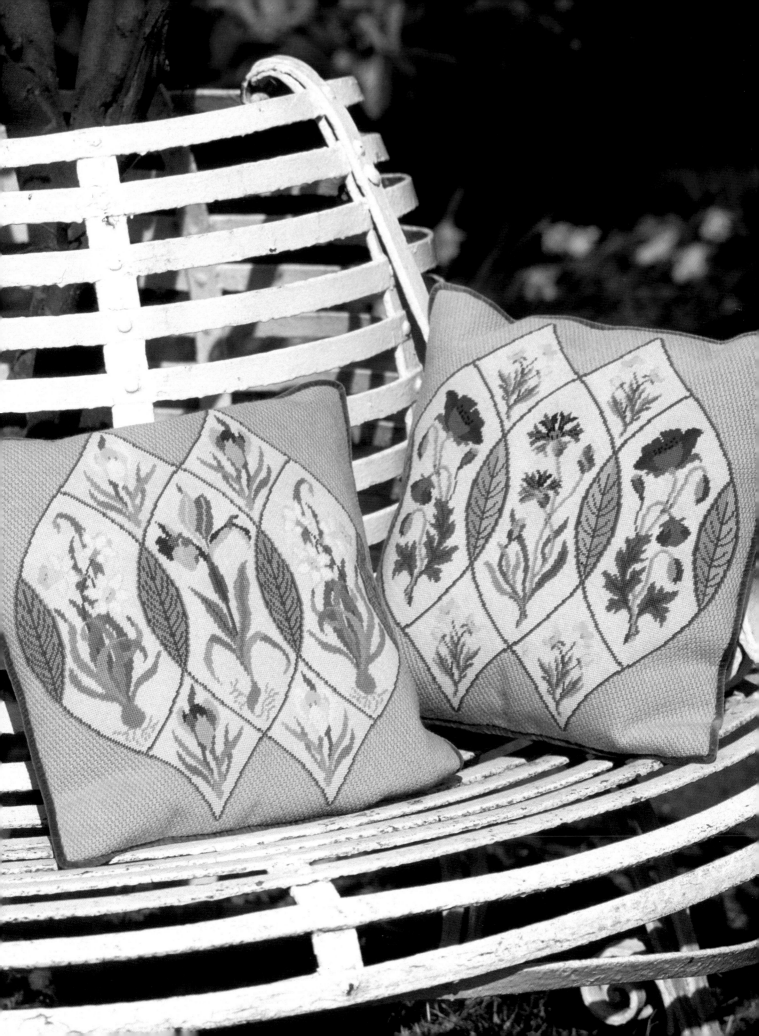

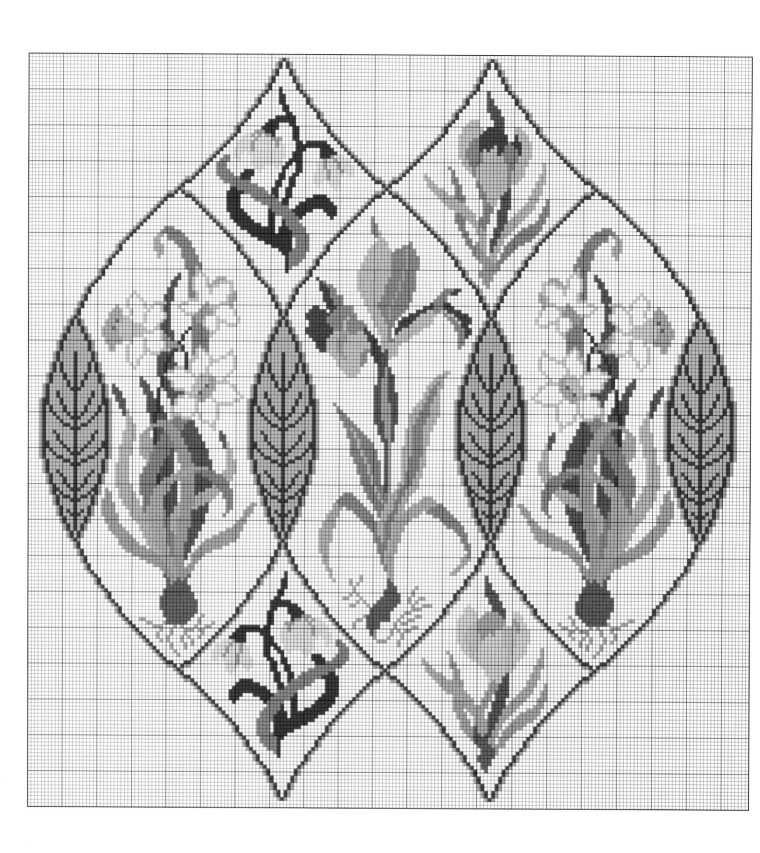

INSTRUCTIONS
Country Flowers, Spring

Design size:

- 207 x 201 stitches
- 38 x 37 cm (15 x 14½ in)
- Finished cushion: 41 x 41 cm (16 x 16 in)
- Finished tabletop: 45 x 45 cm (17½ x 17½ in)

Materials:

- 14-count single canvas, 10 cm (4 in) larger in width and length than the intended stitched area, including the background
- Size 20 tapestry needle

Appleton crewel wool:

- lightest green (352) – 1 skein
- light yellow green (543) – 4 skeins
- light blue green (401) – 1 hank
- darker blue green (402) – 2 skeins
- dark green (355) – 2 skeins
- darkest green (356) – 4 skeins

- pale yellow (872) – 2 skeins
- mid yellow (551) – 2 skeins
- bright yellow (553) – 1 skein
- light mauve (884) – 1 skein
- mid mauve (101) – 1 skein
- dark mauve (104) – 1 skein

- light brown (761) – 1 skein
- dark brown (763) – 1 skein
- white for snowdrop (991) – 1 skein
- pastel grey background (875) – 2 hanks and darker pastel grey outer background (886) – 2 hanks. An alternative dark brown background (558) – 6 hanks, can be used for the tabletop design

Order of stitching

If you have decided to extend this highly adaptable design Use the information on page 111 to help calculate the extra background wool you will need. Buy all of it at the outset to ensure that it is all from the same dye lot.

Refer to page 108 for how to prepare for stitching.

The design and central background area is all worked in tent stitch using three threads of wool in the needle. The decorative outer background has been stitched in cashmere stitch (see page 118).

Start stitching from the centre. When you reach the outline it can be helpful to complete this before adding the rest of the flowers. Complete the design before stitching the inner background with the outer background last of all. Use pale yellow (872) for the daffodil petals.

If you use cashmere stitch to work the background you will need to adjust the length of the stitches to fit around the design.

To help to stitch the flowers facing the opposite way, a mirror can be propped upright next to the chart. Alternatively ask your local colour photocopying shop for a mirror image of the chart.

INSTRUCTIONS
Country Flowers, Summer

Order of stitching

Follow the instructions for *Spring*. The centre of the design is
below the smaller cornflower. Count from there to start. The
daisy is an alternative to the buttercups as a small motif. You
will need a skein each of pink (222) and white (993) as
indicated below.

Design size:

- 207 x 201 stitches
- 38 x 37 cm (15 x 14½ in)

Materials:

- 14-count single canvas, 10 cm (4 in) larger in
 width and length than the intended stitched area
- Size 20 tapestry needle

Appleton crewel wool:

- light green (542) – 4 skeins
- lightest green (351) – 2 skeins
- dark green (355) – 1 hank
- darkest green (294) – 4 skeins
- bright orange (444) – 1 skein
- bright orange red (448) – 1 skein
- dark red (504) – 1 skein
- light blue (462) – 1 skein
- mid blue (463) – 1 skein
- darkest blue (464) – 1 skein

- light yellow (551) – 1 skein
- mid yellow (552) – 1 skein
- dark yellow (553) – 1 skein
- pale mauve (602) – 1 skein
- black (993) – 1 skein
- white for daisy (991) – 1 skein
- pink for daisy (222) – 1 skein
- pastel grey for background (875) –
 2 hanks and darker pastel grey for
 outer background (886) – 2 hanks

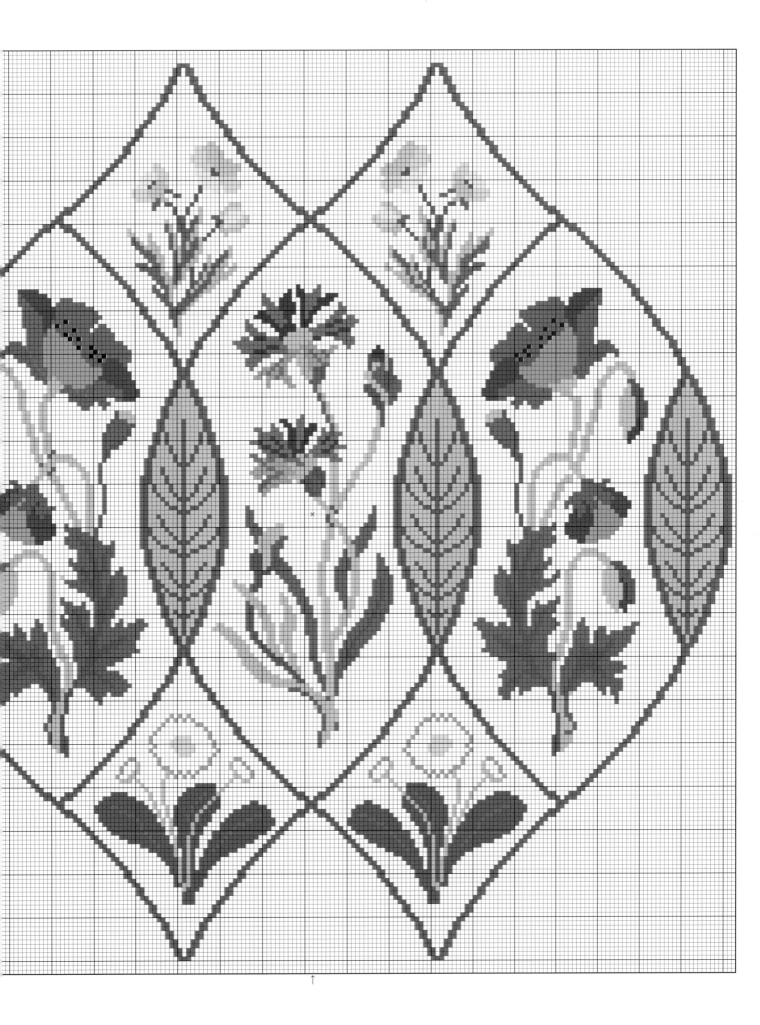

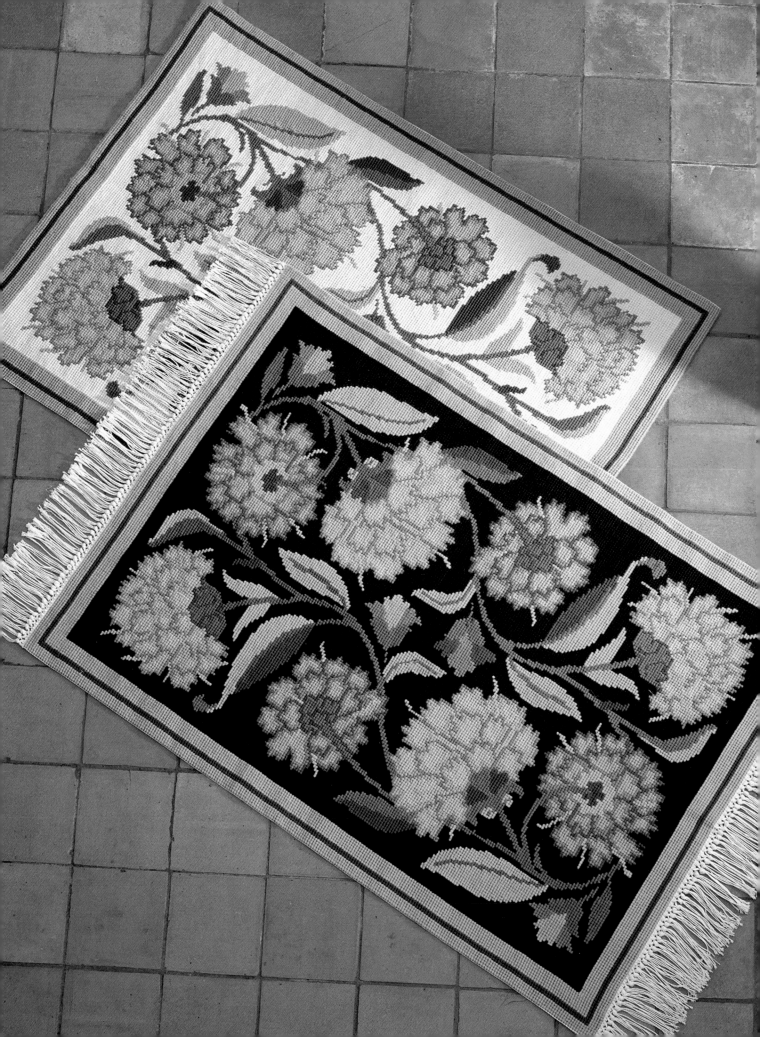

FLOWER TILES

I have long coveted William De Morgan's tiles. As a friend and colleague of William Morris, they worked together on many designs. De Morgan combined the techniques of lustre decoration with the artistry of the Pre-Raphaelite period to create a wealth of ceramics – dishes, vases, tiles – many of which are now valuable assets in private and public collections throughout the world.

De Morgan's fabulous creations caused me problems, though, because the bright glaze colours do not reproduce well in wool. I have contented myself therefore with his excellent draughtsmanship and have tried to match the colours as closely as possible from Appleton's wide range.

Many years ago, I started work on a needlepoint version of one of De Morgan's exotic peacocks, but the wonderful simplicity of needlepoint 'tiles' came some time later. The charming single *Rose* and his stylized interpretation of *Carnation* can be seen at the Victoria and Albert Museum in London. As needlepoint projects, they have many advantages. They are the easiest in the book, and they can be stitched in the shortest time with the minimum amount of concentration. They are small and thus portable – perfect for a long journey, a holiday or as an introduction to needlepoint. They can be made into scatter cushions, or sewn together with other 'tiles' to form a rug – the

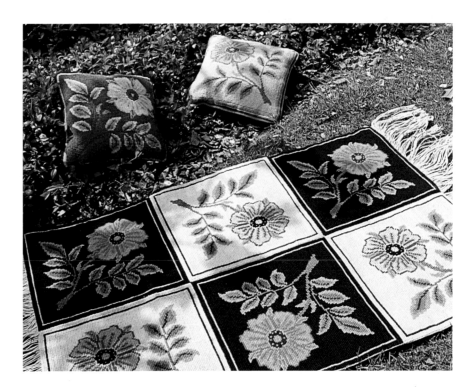

Left:
The *Chrysanthemum* rug, shown with the original cream and a dramatic charcoal background.

Right:
The *Rose Tile* rug and two cushions (worked in different colourways), shown in the garden at Standen.

idea being that you do not need to carry around (or invest in) the complete materials for a rug at the outset, but can work on it in small, manageable sections. The pink and blue colourways with dark blue and light grey backgrounds give the classic effect of De Morgan's own work.

These tile designs also look charming in miniature, worked on fine canvas, as covers or cushions for dolls' furniture or as pincushions.

The *Carnation Tile* has a more overall design – again, I used two of the original colour schemes and the cream background. The choice of brown as an alternative is my own invention. The complementary colours could also be combined to make an attractive rug.

The *Carnation Cushion* is worked on a finer canvas and shows the design closer in size to De Morgan's original tiles. It is worked from the same charts, but with the flowers tilted four ways.

The *Chrysanthemum* series of tiles from which my rug design evolved is quite luscious. It features full, fat flowers and curling leaves – how beautiful they must have looked in a bathroom! Sadly, the very bright turquoise fronds looked garish in wool so I had to leave them out; I also replaced the turquoise buds with lavender and pink ones. I had to end the leaves naturally so that they did not run off the edge, and I added a border. The leaves could not be shaded on the coarser canvas so they were simplified. Despite all this, the colours and the feeling are as close as I could make them to De Morgan's.

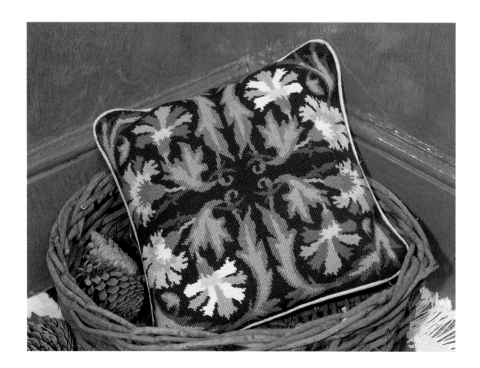

Left:
A *Carnation* cushion made by stitching four tiles together on finer 12-count canvas (see page 102–104).

Right:
Red walls provide a dramatic background to the *Carnation* cushion and rug.

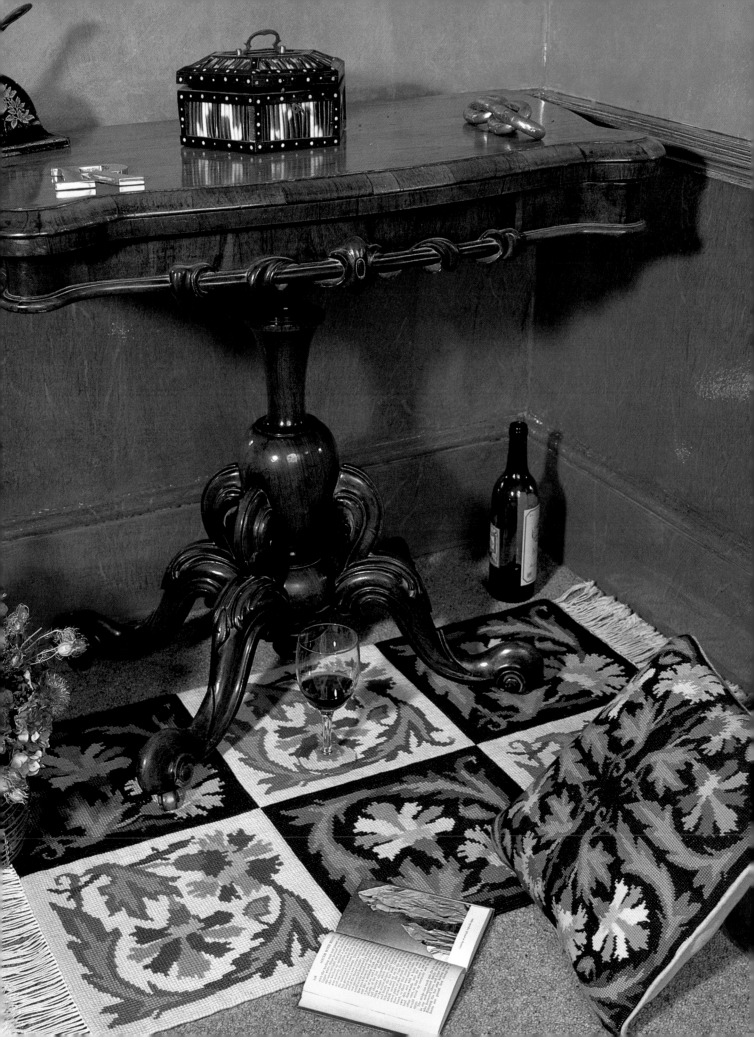

INSTRUCTIONS
Rose Tile

Order of stitching

If you intend to make a rug, before you cut the canvas into exact squares note and, if necessary, carefully mark the direction of the selvedge. The count of canvas always varies slightly on the warp and the weft. See *Carnation Tile* page 102 for details on making a tiled rug.

The *Rose Tile* is stitched in cross-stitch using four threads of wool in the needle. Start in the centre of the tile. Each square represents a cross stitch. Work the design before the background. Stitch five extra stitches of background around each tile.

Two colourways are given below, Pink Rose and Blue Rose. The blue version is stitched simply by substituting the colours given in italics in the table below.

Although we have stitched the pink rose with the dark background and the blue with the light there is no reason why these could not be reversed. For the rug in the photograph, one row of the alternative background colour was stitched on the fourth row in from the edge of each tile.

If you decide to stitch a border make allowances for this beforehand.

Appleton crewel wool:

Pink Rose *and Blue Rose*

- light pink (221) – 1 hank
 or pale blue (561)

- mid pink (222) – 2 skeins
 or mid blue (563)

- dark pink (223) – 2 skeins
 or dark blue (565)

- light green (352) – 1 hank

- mid green (402) – 1 hank

- dark green (405) – 2 skeins

- dark terracotta (128) – 2 skeins
 or charcoal (998)

- dark blue (929) – 3 hanks
 or light grey blue (875)

Design size:
- 78 x 75 stitches
- 27.5 x 27.5 cm (10¾ x 10¾ in)

Materials:
- 7- or 8-count single canvas, 40 x 40 cm (16 x 16 in)
- Size 16 tapestry needle

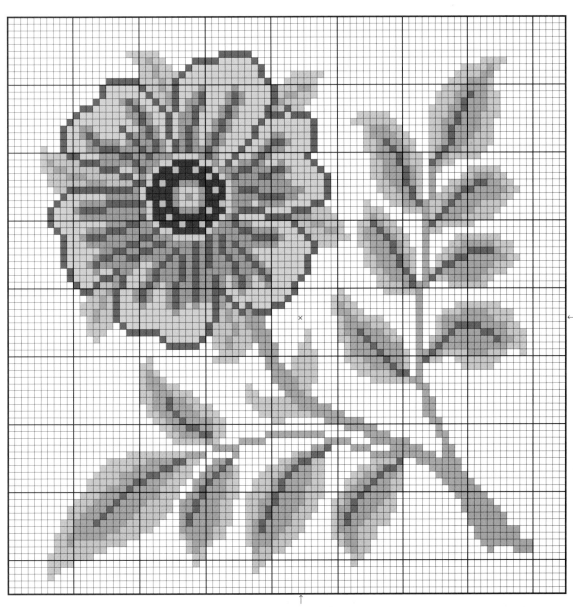

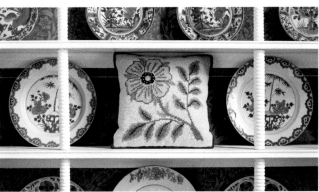

Right:
A most appropriate place for a De
Morgan tile design – the *Rose Tile*
cushion is quite at home with this lovely
collection of china at Kelmscott Manor.

INSTRUCTIONS
Carnation Tile

Order of stitching

Refer to page 108 for how to prepare for stitching.

Before you cut the canvas into exact squares note and, if necessary, carefully mark the direction of the selvedge. The count of canvas always varies slightly on the warp and the weft.

If you are making a rug, the selvedge must run down the length of the canvas. It is important to ensure that each individual tile has its selvedge running in the same direction. Now plan the position of the carnations before you start so that, with the canvas in the correct position, you ensure all the stitches will lie in the same direction on the finished rug.

Each *Carnation Tile* is stitched in cross stitch using four threads of wool in the needle (see page 118).

Start in the centre of the tile. Note that the X in the lower corner of the chart is the centre of the cushion. Each square represents a cross stitch. Work the design before the background. Stitch three extra stitches of background around each tile.

If you decide to stitch the rug in one piece instead of separate tiles, the making up will, of course, be much easier.

Decide on the size of rug you want and choose a suitable canvas. If you use 6-count canvas the rug (as in the photograph) will measure 71 x 107 cm (28 x 42 in). You can then use two threads of tapestry wool in the needle for cross stitch. See page 110 for information on changing the size of the design. You will also need additional wool.

Make sure that the canvas is large enough for the stitching with preferably 8 cm (3 in) extra all round. Find the centre of the canvas and mark the centre line of both the length and width with a hard pencil or by basting with a brightly coloured thread. The shorter line, across the width, will serve as a central line for the two middle tiles. Count 45 threads along this in both directions from the central long line and mark each as the centre point of your first two tiles. Similarly count and mark the position of the other four.

Design size:
- 85 x 84 stitches
- 28.5 x 28.5 cm (11¼ x 11¼ in)

Materials:
- 7- or 8-count Zweigart rug canvas, 40 x 40 cm (16 x 16 in)
- Size 16 tapestry needle

Appleton crewel wool:

- very pale yellow (841) – 1 hank

- mid yellow (471) – 1 hank

- dark yellow (694) — 1 hank

- light green (251) – 1 hank

- mid green (242) – 1½ hanks

- dark green (244) – 1 hank

- dark brown background (585) – 3 hanks

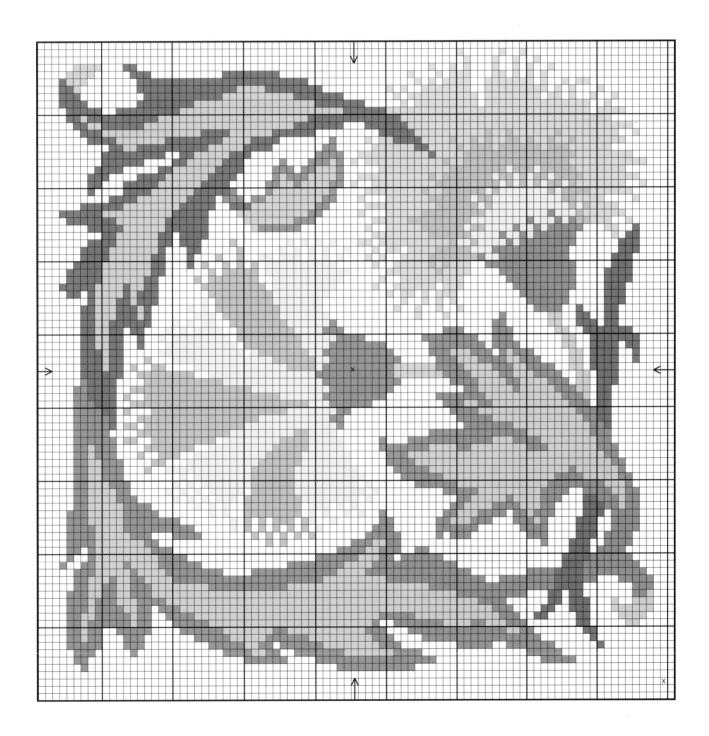

103

INSTRUCTIONS
Carnation Cushion

Order of stitching

Refer to page 108 for how to prepare for stitching.

The X in the lower corner of each chart is the centre mark of the whole cushion. Count from here to the green leaves and start stitching here near the centre of the canvas. Complete the whole tile design before positioning the second chart and working that design in a similar way.

The charts need to be turned upside down for the other half of the cushion. The centre point needs to be found and registered each time. Make sure the designs are equidistant. Work the background last of all.

Design size:
- 173 x 173 stitches
- 37 x 37 cm (14½ x 14½ in)

Materials:
- 12-count single canvas, 50 x 50 cm (20 x 20 in)
- Size 18 tapestry needle

Appleton tapestry wool:

- very pale yellow (841) – 4 skeins
- mid yellow (471) – 4 skeins
- dark yellow (694) – 4 skeins
- dark red (207) – 4 skeins

- light green (251) – 1 hank
- mid green (242) – 1 hank
- dark green (244) – 4 skeins
- dark brown background (585) – 4 hanks

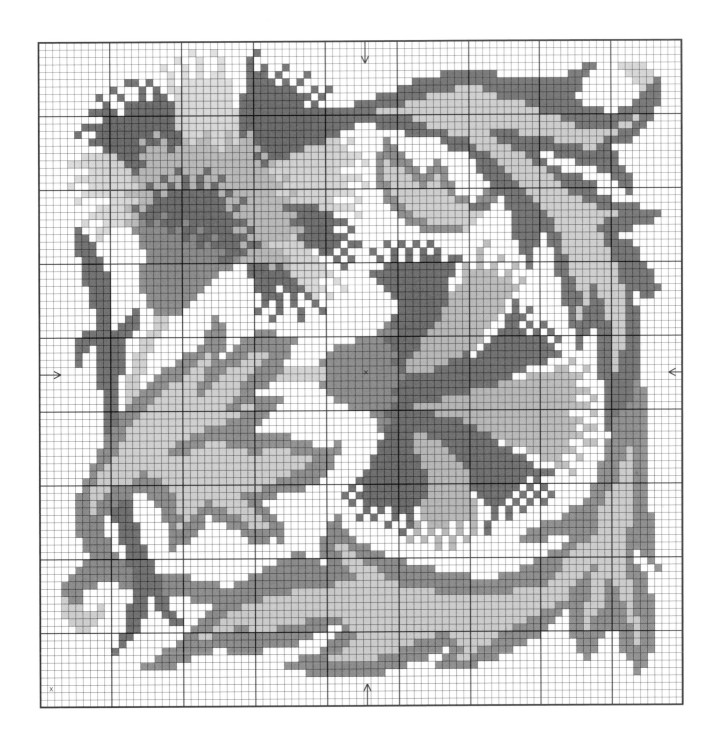

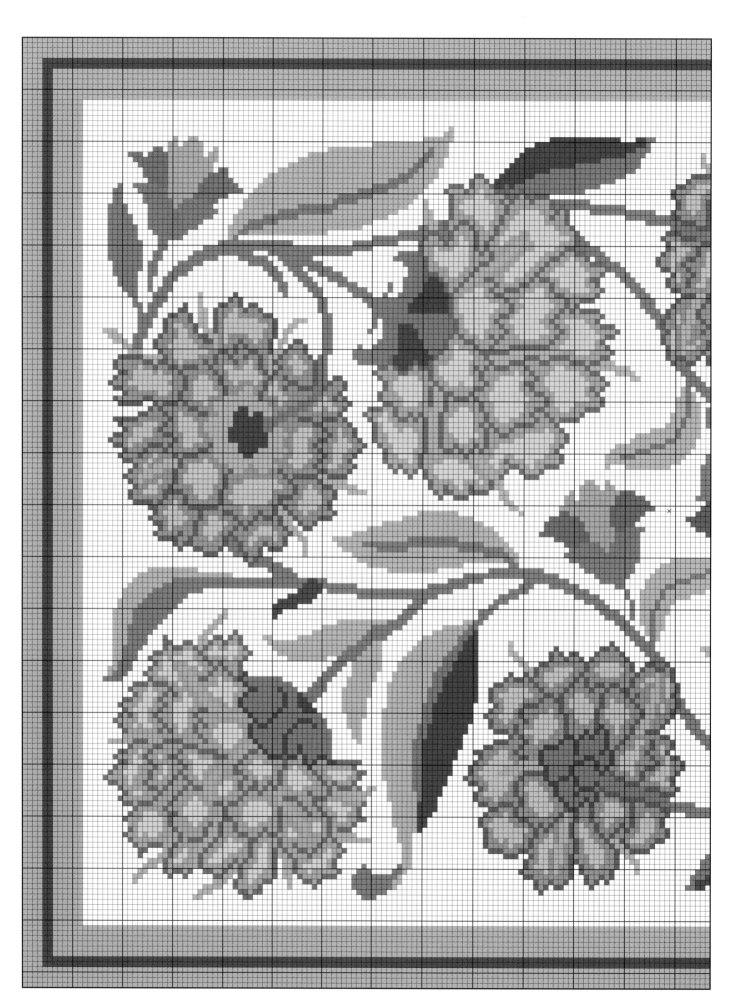

INSTRUCTIONS
Chrysanthemum Rug

Order of stitching

Find the centre of the canvas by folding in half both ways. Baste along these folds with brightly coloured sewing thread to quarter the design and help with counting.

If you have decided to use a frame see pages 112–113. This is a large canvas and if you are not using a frame you might find it helpful to roll the canvas at both ends leaving just the part you are to work on; the rolls can be secured out of your way with a large safety pin (a nappy pin is ideal) or a few large stitches.

The whole design is worked in cross stitch using two threads of wool in the needle – see page 118.

Start by counting from the centre of the chart to one of the buds and stitch this first. Each square on the chart represents one cross stitch. Work the design before the background. When half is complete, turn the chart upside down and stitch the second half. Note that the central buds are stitched in different colours, one in blues and one in pinks. Suggestions on how to complete and back your rug are on page 121.

Design size:
- 259 x 183 stitches
- 110 cm x 77 cm (43 x 30½ in)

Materials:
- 6-count Zweigart rug canvas, 130 x 100 cm (51 x 39½ in)
- Size 16 tapestry needle

Appleton tapestry wool:

- pale pink (141) – 2 hanks
- mid pink (142) – 2 hanks
- dark pink (143) – 1½ hanks
- pale blue (741) – 2 hanks
- mid blue (743) – 2 hanks

- dark blue (746) – 1½ hanks
- light green (352) – 12 hanks
- mid green (355) – 3½ hanks
- darkest green (294) – 2½ hanks
- ivory (882) – 13 hanks

NEEDLEPOINT BASICS

William Morris advocated 'art made by the people and for the people as a joy both to the maker and the user'. Once you have become involved in the creativity of needlepoint and completed your first piece of work, you will want to repeat the process again and again.

The designs in this book vary in their complexity only by the quantity of colours and the size and mesh of the canvas. The same basic rules apply to all of them. I would hesitate to recommend a beginner to start with *Acanthus* (page 74), but with a little practice on small projects all the designs are undoubtedly well within your scope.

Before beginning the embroidery, there are some basic decisions to be made. Which design do you prefer? What use will it be put to? Where is it likely to be placed in the home? Once these points are settled, you can then choose the most suitable canvas and threads.

All the designs are stitched on single (mono) canvas or interlocked rug canvas. The thread quantities quoted are for the size and mesh of the canvas used for the pieces of work illustrated in the photographs. It might be simpler, for your first project, to stay with the same format. If you want to change the colours to suit a particular room setting, this is easy to do if you take a little care. The *Magpies* design (page 66) is a good example. Sometimes a change of background colour is sufficient, as in *Wild Flowers* (page 48) and *Lodden* (page 34). If you are not sure how the colours will look together, work a sample of the design first.

How to start

Whatever you decide to make, you need to mark out the background area. If you are making a fitted design, such as a chair seat, see page 114 to make a template.

Start in the centre of the canvas. Fold the canvas in half each way, then mark the folds by basting along them with bright-coloured sewing thread. This divides the design into quarters which makes it easier for you to count from the chart.

If you decide to use a frame, now is the time to fix the canvas to it. Otherwise, you may want to overstitch or bind the edges of the canvas to prevent them fraying and catching your clothes. Identify all your threads – it may help to label each shade with the corresponding Appleton's wool code from the chart. You do not have to use wool (see 'Threads', page 110). The colours quoted in the key to each chart apply to that chart only. If you have some yarn left over and wish to use it for another project, check you have the right colours by referring to the Appleton's code numbers rather than the names.

Find the centre of the chart and thread your needle with the colour nearest to that point. Use the specified number of threads in the needle, to ensure good coverage of the canvas, and knot the end. You are now ready to start stitching.

Take the thread down from above the canvas at a point that will soon be covered by the same, or similar, colour about 4 cm (1½ in) away from the starting point. The thread will be worked over at the back and secured. Cut off the knot when you reach it with your stitching. Finish off either by threading through a line of stitches at the back, or preferably by bringing the thread up 4 cm (1½ in) away from the last stitch and working over it with your new thread before cutting off the loose end.

Stitch the design before the background. Each square on the chart (not intersection) represents one stitch (across an intersection) on the canvas. When the needlepoint is complete, see page 120.

It really is as simple as it sounds, but for those who wish to experiment or who feel secure knowing a little more, here are some technical details.

Choosing the canvas

Canvas is made in a range of materials, including cotton, linen, man-made fibres and plastic. The best-quality canvas readily available is made from polished cotton. A needlepoint embroidery should, with care, last several lifetimes so it makes sense to buy the best you can afford.

There are three main types of canvas: single (or mono), interlocked and double thread (Penelope). All are meant to have an even weave of open-count squares. However, you can sometimes detect a slight difference in the length and width; if you ever need to join two pieces, be careful that the selvedges lie in the same direction.

Single canvas consists of a weave of single threads, and is graded according to the number of threads per inch. It is ideal for the tent stitch that is used for most of the designs in this book. Interlocked canvas has the threads twisted so that they 'lock' at the intersections. Double-thread canvas has pairs of threads running each way, and is graded according to the number of double threads per inch. Needlepoint stitches are normally worked over pairs of threads.

The choice of canvas is very much a matter of personal taste, but my preference is for good-quality single canvas. With the exception of firm rug canvases, **interlocked canvas** is often far too thin for hard wear. The interlocking is intended to prevent the canvas threads shifting with the tension of the stitches, but unless the work is firmly framed the canvas is so thin and pliable that it will tend to pull out of shape. It is then extremely difficult to stretch it back, as it will not take any great degree of tension without breaking. My advice is never to use it for chair seats or anything large, and always use a frame. Rug canvas is the exception to this rule; all the rugs in this book are designed to be embroidered in cross stitch on a strong, interlocked rug canvas with either six or eight threads to the inch.

Double canvas has two advantages over the others. As the threads run in pairs in each direction, a 12-count canvas, which would normally be worked with the stitches crossing pairs of threads, can be transformed into a much finer 24-count canvas by separating the pairs and stitching over one thread only. This is generally done when intricate details are required, for example, to stitch the features of a face. Sometimes the entire design area may be worked this way, in *petit point*, leaving the background to be worked over pairs of threads in *gros point*.

The second advantage of double canvas is that it may be trammed. When needlepoint embroidery is trammed, long stitches are run across the canvas, to be covered later by tent stitches in the same colour. The whole design is trammed before the real stitching begins, and decisions about where colours should lie are taken at this early stage. Devotees of tramming believe that it increases the wear of the article by leaving a double thickness of thread on the surface. One could, however, argue that the topstitching will wear as soon and need repair just like an untrammed canvas.

When buying canvas, always allow for at least 5 cm (2 in) of spare canvas all round the required finished size of the embroidery for stretching or blocking and finishing.

Changing the size of the design

If you want to enlarge or reduce the design, you will need a different mesh canvas. Simply divide the number of stitches in the design (quoted on each pattern page) by the size required (not including the background). The answer will be the canvas mesh you need. Check both the width and height of the design.

For example, if you want a design 30 cm (12 in) wide and the number of the stitches on the chart is 144, you will need 12-count canvas. If the division does not produce a round number, choose a finer mesh and make up the extra size in the background colour.

Threads

I have used my favourite Appleton yarns because of their fabulous range of colours. Each shade is produced in both crewel and tapestry wool.

Crewel is a fine, twisted, 2-ply yarn, which may be used as a single thread (as in the doll's chair background) or up to five or six threads in the needle for the coarsest canvas. Threading several

Right:
The contents of one of my Designer's Forum kits, which contain all you need to make up your chosen design.

110

strands into the needle may sound a nuisance, but you will find it is quite simple to do. The advantages are that the wool lies very flat when worked, it is more hard-wearing and you have the opportunity to experiment with blending the shades in the needle. If the shades are close, you will create a new colour (as in the background of *Acanthus*, page 74). If they are quite contrasting, then you will have an interesting tweedy effect. The mixing of colours works well in *Tiffany Window* (page 44), where the clouds blend gently into the sky with no harsh edges.

Tapestry wool is thicker and softer than crewel wool, the equivalent of 4-ply yarn. There is no reason why you should not use it in any of the designs in this book if they are on a 14-count or coarser count canvas, and if you do not need to blend shades in the needle. I have used it for the rugs on coarser 6-count canvas with two threads of wool in the needle using a cross stitch which covers the canvas more efficiently.

Although my preference is for Appleton yarns because of the excellent range of colours, you may be accustomed to another brand. Take a little time to choose complementary colours. There are also many types of cotton and silk threads – stranded and twisted, with shiny and matt finishes. These threads will not wear as well as wool and are generally more suited to finer work – the design on the doll's chair was worked in a mixture of the two. They are more expensive than wool but provide an even greater range of colours and textures to play with. Either can be used with wool to great effect – the sheen provided by a group, or line, of silk stitches next to wool brings to life the light on a wet leaf; black silk would give the eyes of the *Magpies* a gleam; and the feathers on the birds in *Tiffany Window* can be made to shine in the sunlight. Experiment with other threads – you will find it most rewarding.

To calculate quantities of wool, the general rule is that one hank of wool, which weighs 25 grams (just under 1 oz), will cover an area 15 x 15 cm (6 x 6 in) in tent stitch. This has to be approximate, and it does assume that you are using enough wool in the needle to cover the canvas and not so much that it is difficult to pull through. One hank equals six skeins of wool.

If you need to be very precise in your estimates, you can stitch a sample square and note exactly how much wool is used: allow more than the eventual calculation as you have to take into account the irregularities of shapes around the design. Generally, longer stitches use less wool even though an extra strand of crewel wool would be needed.

It is not crucial if you underestimate the quantities of wool for the design – if the dye has changed, you will have an extra shade to work with. The background wool is more important; even the slightest change will show when stitching and this cannot always be readily noticed simply by holding the hanks together in your hand. If you have to buy extra wool for the background, try and find the same dye lot, although dye lot numbers are not always shown on embroidery threads. Always blend some of the old thread with the new in the needle for a few rows to prevent a hard line. This is only possible with crewel wool; if you are using tapestry wool, try to stagger the line between the old and new.

Needles

The blunt-ended, large-eyed tapestry needles come in sizes 13 (for the coarsest canvas) to 26 (for very fine work). The needle needs to be easily threaded with the required thickness of wool and

to be able to pass through the canvas without tugging. Appropriate needle sizes are given for each of the designs in the book and are generally 22 for 18- or 17-count canvas, 20 for 14- or 13-count canvas, 18 for 12- or 10-count, and 16 for 8- or 6-count canvas. When I work, I like to have several needles, each threaded with a different colour.

Frames

Not everyone enjoys using a frame, but they do have several advantages. By keeping the canvas evenly stretched, a frame minimizes the distorting effect of diagonal stitches. Both hands are free so that one hand may be used above and one below the canvas, passing the needle through from one to the other, which speeds up the stitching process. The stitches are also more even than those made with the single 'scooping' movement used when the canvas is hand-held.

The golden rule is that each embroiderer should enjoy the work, so decide which type of frame, if any, is most suitable for you. There are three main types of frame to choose from:

Slate frame

Slate frames are used by professional embroiderers. They can be rested on trestles, against a table or attached to a floor stand.

This is a strong frame, heavier than other frames, and enables the canvas to be pulled very taut. It consists of two roller bars with webbing, and two side pieces that slot into the rollers at top and bottom. These are held in place either with split pins or wooden screws. The rather time-consuming process of framing up is rewarded by the ease of stitching.

Travel frame

This is a lighter, less substantial version of the slate frame, with shorter side bars, exposing less of the canvas. The side bars are attached to the roller bar with wing nuts, so an even tension cannot be achieved as the nuts tend to slip. This frame, however, is easy to dismantle and transport.

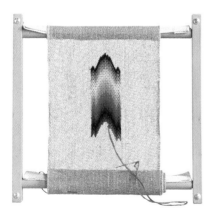

The size of the frame you will need is determined by the width of the canvas. The webbing on the frame, which denotes its size, must not be smaller than the canvas width. The length of the canvas is less important as the excess can be rolled round the bars, and worked in sections.

Ring or hoop frame

More often used for surface embroidery, this kind of frame can also be suitable for smaller pieces of canvaswork. The canvas is stretched over the inner ring, the outer ring holding it firmly in place. A hoop can be used with a table or floor stand, but the work must be removed from the frame after every session. Unless the piece is very small, you will need to move the ring from area to area as you work. Clearly, the work is portable, with or without the hoop.

Some embroiderers believe that the hoop marks the work, but I have found that any creases are removed in the stretching process.

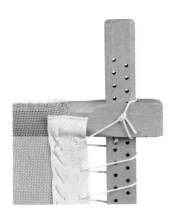

How to frame on a slate frame

You will need webbing, button thread and string. Mark the centre of the canvas by folding the canvas in half each way and basting along the folds with bright-coloured sewing thread. Sew a strip of webbing to each side of the canvas, using button thread and straight or slanting stitches 2.5 cm (1 in) in from the edge of the canvas, as shown (left). (You can, if you prefer, machine stitch this.)

Fold the canvas under 1 cm (½ in) at top and bottom. Match the centre to the centre of the webbing on the frame bars. Pin from the centre outwards and oversew. At all times, use the threads of the canvas to ensure that everything is exactly square.

Insert the slats into the ends of the frame bars and position the pegs an equal number of holes from the top. Repeat at the bottom, pulling as tightly as possible. If the canvas is too long, you may need to roll it round the tape bars, leaving the centre exposed. When the exposed part is complete, you will need to unstring and re-roll the canvas, and then re-string.

To string the canvas, use a large-eyed needle (a packing needle is ideal). Lace the string between the side bars and the side webbing, pull it up as tightly as possible and knot the string securely. The canvas must be absolutely square and taut.

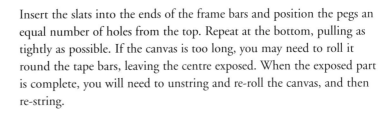

Making a template

For special shapes, such as a chair seat, you will need a template, an exact replica of the shape you wish to cover. An upholsterer can supply you with one, or you can make one yourself with a square of old sheeting or muslin. This will indicate the complete area to be stitched. If the chair has lost its stuffing, pad it out to its anticipated shape before starting.

Fold the template fabric in half in both directions to find the centre and mark the centre lines – horizontally and vertically. Lay it squarely on the seat and hold in place along the centre (measuring first to find the centre of the seat). Smooth the template down and mark carefully round the line of the outside area, where there may already be a line of upholsterer's tacks – this should be to the outer extremities of the tacked area, leaving the unworked canvas for tucking in.

If the chair has a long drop at the front, it is possible that the centre of the template will not fall in the centre of the seat (i.e. where the centre of the design should also be). Mark the ideal design centre onto the template. Trim round the outline. Your canvas should be at least 5 cm (2 in) larger all round. Tidy the outline of the template either on the fabric or by transferring it to paper. Check that the shape is symmetrical.

Lay the template on the canvas and mark the centre point to coincide with the centre point of the template, ensuring that the horizontal and vertical lines of the template lie squarely along the threads of the canvas. Mark the canvas round the edges of the template, using indelible ink. Keep the template so that you can check it against your work later, if necessary.

Charts

Although they may appear daunting to the uninitiated, charts offer several advantages over printed canvases.

It is great fun to start with a plain canvas and watch the design grow as you stitch. With a printed canvas, there is less scope for large errors and you add to the colour and texture as you work, but the element of surprise is lacking.

There are moments in the stitching of printed canvases where, for instance, the edge of a petal lies between two canvas threads. A decision must be made as to which thread to cover with your stitches, perhaps making the petal significantly larger or smaller. In charts there is no such ambiguity to contend with.

The most obvious advantage of charts is their adaptability (see opposite).

How to work from a chart

The basic instructions have already been given on page 108. You can mark the centre lines with an indelible pen, but if this is too dark and the thread colour is light you will run the risk of it showing through. If pencil is used, it should be hard as it tends to rub off on the threads, making them dirty. This is why basting is the best option.

Identifying and marking the threads is helpful if you are likely to be working in different lights. Shades that are close may be difficult to distinguish at night.

With a printed canvas, the overlying parts of the design are always worked first. This ensures that where there may be some doubt as to where exactly to place the stitches, the topmost shapes are given priority and a good line. The chart takes away any doubt, so you may stitch in any order you wish. I like to have several needles threaded so that I can progress out from the centre, working on different colours as I come to them without re-threading the needle.

For a symmetrical design, you may find it helpful to stitch the matching section on the other half immediately you have finished the first. Here, again, threaded needles are timesaving.

It is much safer to stitch the design first. If you do miscount and feel you want to unpick, it is very distressing to have to unpick the background too!

In this book, only half of some of the charts for symmetrical designs is shown. When you are working the second half of the design, you can use a mirror propped at right angles against the chart to help you 'see' the other side. I find that following the photograph helps prevent me losing my sense of direction. Where only a quarter of the design is shown as a chart, this is repeated (with the chart turned upside down) in the diagonally opposite quarter. The other two quarters are mirror images of the first two.

Adapting charts

This is the joy of charts. If you want to increase or decrease the size of the design to fit a specific space, this can be done by omitting part of the design, by repeating some parts, or, more simply, by changing the mesh of the canvas (see page 110).

My doll's chair (below) shows how *Lodden I* can be adapted. The canvas mesh is 28 threads to 2.5 cm (1 in), an 'antique' piece, to achieve the finished size of 13 x 13 cm (5 x 5 in). The outer foliage was left out, the two tiny open flowers were moved inwards by nine stitches and joined

Right:
A detail of *Lodden I* – see how the original design is adapted to fit the much smaller square of this doll's chair. The design is worked in silks and cottons, and the background in wool. The canvas is antique, and 28 holes to the inch.

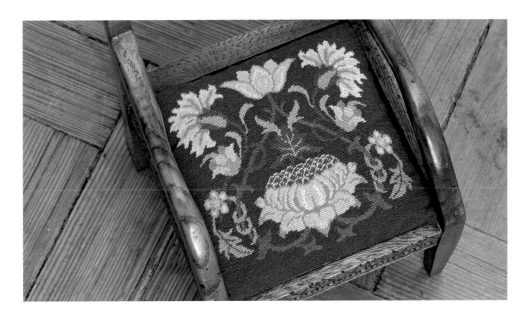

directly to the bud above, and the two leaves were worked on opposite corners so that they curved inwards. This has transformed a rectangular design into a square one without losing any of its charm – and also reduced it to less than half its size.

Country Flowers, Spring (page 90) can be elongated by adding the smaller flowers to each end of the design. They could just as easily have been omitted from the original to make a much narrower design consisting of daffodils and irises only. You could also repeat more of these larger flowers to create a wider piece of embroidery.

Occasionally, just one section of a design is all you need. A particularly appealing example of this use of charts is to be found at Kelmscott Manor, in Gloucestershire, where the birds from *Strawberry Thief II* and *III* (pages 16–25) have been used to decorate the kneelers in the church where William Morris and his family are buried. This was the charming idea of Jean Wells who, with Richard Dufty, has done so much to maintain and enhance Kelmscott Manor on behalf of the Society of Antiquaries (see page 9).

Stitches

Where threads provide colour, stitches give texture to your work. Using a different stitch for the background will emphasize the outline of the design.

Although there are hundreds of needlepoint stitches for you to try, the ones that I have used for the designs in this book are shown on these pages.

My instructions may seem rather precise, but they are meant to help you to achieve the results you see in the photographs. But rules, as we all know, are made to be broken, and with some good evenweave canvas and a needleful of thread what can be more enjoyable than experimenting? You may rediscover some old stitches or invent some new ones. As I am sure I have said before, enjoy yourself – this is your creation.

Tent stitch (Continental)

This is the most frequently used of all needlepoint stitches. It is ideal for describing fine detail and creates a hard-wearing fabric that is excellent for upholstery. The long stitches on the reverse side of the canvas help to cushion and protect the work.

Tent stitch (basketweave)

This is used for larger areas, particularly backgrounds. The 'basket-weave' effect of the stitches on the reverse of the canvas helps to prevent the canvas from becoming distorted. Work each alternate row in the opposite direction to avoid 'ridges'.

Cross stitch

A hard-wearing stitch ideal for rugs and larger pieces, cross stitch also helps to eliminate distortion of the canvas. Work half crosses first, then return across the row working the second part of each cross. Make sure that all the crosses are formed in the same way, with the top stitches all lying in the same direction.

Cashmere stitch

This is a useful stitch for creating a textured effect over large areas of background. It is harder-wearing than gobelin filling, but not as durable as tent stitch.

Gobelin filling

A useful stitch for covering background areas quickly and creating an attractive textured effect. It is not as hard-wearing as tent stitch, so is not recommended for chair seats, for example. If you are using crewel wool you will need an extra thread in the needle to cover the canvas adequately.

Brick stitch

Similar in appearance to gobelin filling, this is useful for backgrounds. It does not wear as well as tent or cross stitch. If you are using crewel wool you will need an extra thread in the needle to cover the canvas adequately.

Note: When you are working long stitches such as gobelin filling, cashmere or brick stitch, adjust their length where necesssary to accommodate the design.

Stitching

If you will be stitching with the work held in your hand, before you begin you may prefer to hem the edges of the canvas or seal them with strips of masking tape in order to prevent them fraying or snagging on your clothes. You will find it easier to work if you roll the canvas up, leaving exposed only the area on which you are working.

How you should start and finish is explained earlier on page 108. The number of threads to be used in the needle should be sufficient to cover the canvas without being difficult to pull through the holes.

The longest thread which I would recommend is 77 cm (30 in), and this is also convenient to cut from an Appleton's hank. Longer threads may become thin by pulling through the canvas too frequently, and they may also knot and interfere with the rhythm of your work.

It is better to make stitches in two distinct movements, inserting the needle with the top hand and pushing it back up with the lower hand. This is easy if you are using a frame, but not so easy if the work is held in the hand. 'Scooping' your stitches in a single movement, although quicker, causes greater distortion of the canvas, but if you have always stitched this way you will have found that the finished work can be 'stretched' back into shape provided your tension is not too tight.

Stretching or blocking

As you stitch, even if you are using a frame, the diagonal slope of the stitches will gradually pull the canvas more and more out of true. Fortunately, both canvas and wool are pliable enough to be pulled back into shape by stretching.

To stretch a needlepoint, you will require the following: carpet tacks or fine stainless steel nails; a hammer; a large set-square (T-square); a clean cloth, larger than the canvas; and a clean board. The board must be larger than the canvas and soft enough to take tacks easily. An old clean table, or even a wooden floor, might be suitable for a rug, but remember you will mark the wood.

Pin the cloth to the board. Dampen the back of the needlepoint and lay it face down on the cloth. Line up one edge of the needlepoint with a ruler or the edge of the board and tack it in place, placing the tacks 2.5 cm (1 in) away from the edge of the stitching and approximately 12 mm (½ in) apart. Do not hammer them home as they will almost certainly need to be moved.

Pull the canvas and tack down an adjacent edge, using the set-square to check that the corner is a right angle. Continue round the edge, re-damping the work and pulling it, replacing tacks as necessary. When you have finished, the worked piece should be taut, with right-angled corners. This process is hard on the hands and takes a good deal of strength. The final tacks may need to be fixed at 2.5 cm (1 in) intervals. If you have used a template, it will fit perfectly if the canvas is stretched correctly.

Allow the canvas to dry out slowly, leaving it for at least 36 hours before you remove the tacks. If the piece has been very badly pulled out of shape, you may need to repeat the process several times.

Mounting for framing

If you intend to frame your finished needlepoint like *Daffodils* (right), it must first be backed. You will need a piece of heavy card, calico, thread, pins and glue.

After stretching the embroidery, measure and cut the card to the exact finished worked size. Cut the calico approximately 13 cm (5 in) larger each way than the card. Place the card over the calico; cut across the corners of the calico at an angle, and bring the edges to the back of the card. Glue the calico to the board, putting glue along the raw edge of the fabric only. Allow the glue to dry.

Trim the canvas to leave an unworked border of approximately 2.5 cm (1 in) all round, and cut diagonally across at the corners. Lay the covered side of the board on the wrong side of the needlepoint. Bring the edges of the canvas up over the board, and hold them in place by pinning through the edge of the unworked border into the thickness of the board.

Make sure that the needlepoint is correctly positioned and is held firmly, then herringbone stitch the unworked canvas border to the calico at the back of the board. Stitch just inside the glued edge of the calico and mitre the corners. Remove the pins and back with a piece of cotton or suitable fabric, slip stitching all round.

Lining and backing rugs

Stretching or blocking will improve the look of a rug, even if it has not lost its shape during stitching. If you cannot do this, it will benefit from pressing on the wrong side with a damp cloth. If the rug is out of shape, it must be stretched, either at home or professionally.

The type of backing you choose will depend in part on the use to which you intend to put the rug. A floor rug will require a more substantial backing than a rug that is to be used as a wall hanging or a sofa throw.

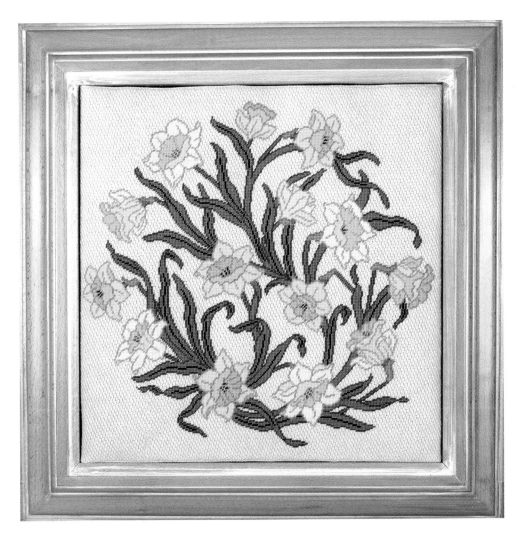

Right:
Daffodils (see page 58), framed in pickled pine.

After stretching, trim the unworked canvas leaving 5–7.5 cm (2–3 in) all round.

Fold the unworked canvas to the back and herringbone stitch it to the reverse side of the rug, using strong cotton thread; mitre the corners. Cut the lining to the finished worked size of the rug, plus a seam allowance of approximately 2.5 cm (1 in) all round.

Fold the lining in half both ways and mark the fold lines. Repeat on the rug. Place the lining on the back of the rug, matching the marked fold lines. Stab stitch along the marked centre lines from top to bottom and from side to side. Take a small stitch through the lining and rug and bring the needle back up, running the thread under the lining to make the next stitch. It may be advisable to make further rows of stab stitching at either side of the central line, to prevent sagging. Turn under the seam allowance of the lining and slip stitch it to the rug at the edges.

If the rug might need to take hard wear, it should be interlined with a firm curtain interlining felt, or even a carpet underfelt. Cut the interlining to the same size as the finished embroidery (seam allowances are not needed) and attach it as described above for the lining. Holland, Union cloth or a similar fabric can then be used for a final backing. Make sure that both the interlining and the backing are neatly and firmly stitched to the rug at the edges.

Making up a tiled rug
It is essential to ensure that the individual tile canvases are absolutely square – they may need stretching or at least careful ironing on the wrong side. Check with a set square.

Join the squares so that the selvedge sides all run down the length of the rug. Each adjoining side must have the same number of stitches so that the squares can be joined stitch for stitch.

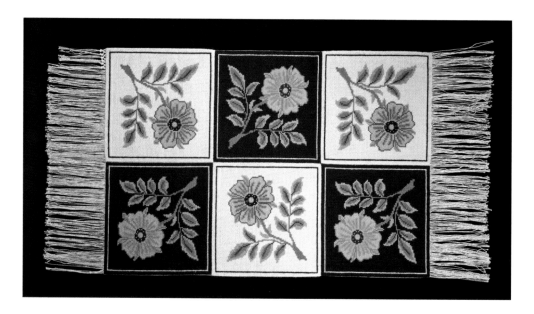

Right:
An example of a long fringe intended for decorative knotting.

Join the tiles by back stitching with double button thread. When complete, tidy up the back of the rug by herringbone stitching the loose edge of the canvas so that it lies flat. Mitre the corners. Finish the rug as described above.

Fringing rugs

Add a fringe to the rug after the edges of the canvas have been turned back and stitched to the reverse side, and before the rug has been backed. You will need a crochet hook and fringing twine or wool.

To cut the fringing into equal lengths, wind it round a firm strip of card or wooden slat of the correct width, then cut along one edge. To make a fringe 7.5 cm (3 in) deep, for example, you will need a 7.5 cm (3 in) wide strip of card, which will produce 15 cm (6 in) lengths of fringing. Fold each length of fringing in half and hook the folded loop through a hole at the edge of the finished rug. Thread the two ends through the loop and pull them tight. Repeat along the edge of the rug.

You can have fun knotting the fringe in different ways.

PLACES TO VISIT

If you would like to explore or research more of the Arts & Crafts Movement, here is a list of some of the places in the United Kingdom which house original works. Some are public museums with well-publicized opening times; some are collections in the care of official bodies such as the National Trust or the Society of Antiquaries which are only open on specific dates; others are private homes. With the exception of the museums and galleries, you will need to write for an appointment to visit – a little patience will be well rewarded.

The National Trust
www.nationaltrust.org.uk

Red House, Bexleyheath, Kent (WM)
Standen, East Grinstead, West Sussex (WM)
Wightwick Manor, Wolverhampton, West
 Midlands (WM; DeM)

Museums and Galleries

Brangwyn Hall, Swansea, South Wales (B)
 www.swansea.gov.uk/brangwynhall
Cardiff Castle, Cardiff, South Wales (DeM)
 www.cardiffcastle.com
Castle Museum, Norwich
Cecil Higgins Museum, Bedford
Cheltenham Art Gallery and Museum,
 Cheltenham, Gloucestershire (WM)
 www.artsandcraftsmuseum.org.uk
City Museum & Art Gallery, Birmingham
County Museum & Art Gallery, Leicester
Emery Walker Trust, Hammersmith, London
Fitzwilliam Museum, Cambridge (WM; DeM)
 www.fitzmuseum.cam.ac.uk
Jackfield Tile Museum,
 Ironbridge Gorge, Telford, Shropshire
 www.ironbridge.org.uk

Kelmscott House, Hammersmith, London (WM)
 www.morrissociety.org/Kelmscott_House.html
Kelmscott Manor, Kelmscott, Gloucestershire
 (WM; DeM) www.kelmscottmanor.co.uk
Leighton House, Kensington, London (DeM)
 www.rbkc.gov.uk/leightonhousemuseum
Linley Sambourne House, Kensington, London
Museum & Art Gallery, Bristol
Victoria and Albert Museum, Kensington, London
 (WM; DeM) www.vam.ac.uk
William Morris Gallery, Walthamstow, London
 (WM; DeM; B) www.lbwf.gov.uk
Whitworth Art Gallery, Manchester

WM = William Morris
DeM = William De Morgan
B = Frank Brangwyn

William Morris Society
www.morrissociety.org

Based at Kelmscott House in Hammersmith, London, the William Morris Society has an active programme of lectures, visits, study days and social events, as well as a newsletter and journal. Membership applications should be addressed to Kelmscott House, 26 Upper Mall, Hammersmith, London W6 9TA.

Left:
Detail of *Pimpernel* wallpaper designed by Morris & Co. in the Billiard Room at West Wightwick Manor.

SUPPLIERS

The majority of designs in this book are also part of a collection of over 50 beautifully printed kits available by mail from Beth Russell at Designers Forum, PO Box 565, London SW1V 3PU (http://www.bethrussellneedlepoint.com). Tel: +44 (0)207 798 8151. Fax: +44 (0)207 233 8118. Please contact me for a colour catalogue. For more information about Appleton wools and local stockists, please contact Appleton Bros Ltd, Thames Works, Church Street, Chiswick, London W4 2PE. Tel: +44 (0)208 994 0711. My kits are also available from good needlepoint shops all over the world and in many of these you will also find the Appleton wools, canvas, needles, frames and a finishing service for your work. There are too many to mention every one, but here is a selection:

Australia
Cottage Crafts, Myrtle Bank, SA
Crewel Gobelin, Killara, NSW
Mosman Needlecraft, Mosman, NSW
Needlework Emporium, Sydney, NSW
Needleworld, Hyde Park, SA
Priscilla's Tapestry, Melbourne, VIC
Tapestry Craft, Sydney, NSW
Victoria House, Mittagong, NSW

UK and Europe
Busybodies, Holywood, Northern Ireland
 (tel: 02890 423756)
Creative Crafts & Needlework, Totnes Devon
 (tel: 01803 866002)
Crown Needlework, Hungerford, Berkshire
 (tel: 01488 681630)
David's Needlearts, Arundel, Sussex
 (tel: 01903 882761)
Doughty Bros, Hereford, Herefordshire
 (tel: 01432 352546)
Fabric & Tapestry Shop, Corbridge,
 Northumberland (tel: 01434 632902)
House of Needlework, Shrewsbury, Shropshire
 (tel: 01743 355533)
Liberty, London (tel: 020 7734 1234)
Peachey Ethknits, Maldon, Essex
 (tel: 01621 857102)
Quorn Country Crafts, Loughborough,
 Leicestershire (tel: 01509 211604)
Russells Needlework, Carlisle, Cumbria
 (tel: 01288 543330)

Sherborne Tapestry Centre, Sherborne, Dorset
 (tel: 01935 815361)
Shipston Needlecraft, Shipston-on-Stour,
 Warwichshire (tel: 01608) 661616
Tapestry Garden, Helmsley, Yorkshire
 (tel: 01439 771300)
Threads, Amersham, Buckinghamshire
 (tel: 01494 727700)
Viking Loom, York, Yorkshire
 (tel: 01904 765599)
Wye Needlecraft, Bakewell, Derbyshire
 (tel: 01629 815198)

Belgium
A la Fileuse, 1000 Brussels

Finland
Kasityokori Online, 48101 Kotka

France
Celimene Pompon, 75006 Paris
Sarl les Drolieres, 37600 Loches
Voisine, 92200 Neuilly-sur-Seine

Germany
Gabi Bocher, 42499 Huckeswagen

Japan
Yamanashi Hemslod, Tokyo 150-0001

Netherlands
De Afstap, 1015 Amsterdam

New Zealand
Broomfields, Christchurch
The Embroiderer, Auckland
Nancy's Embroidery, Wellington

Spain
Anoranzas, 28001 Madrid

USA
For details of where to buy Appleton wools and Beth Russell kits in the US contact Potpourri Etc, 275 Church Street, Chillicothe, OH 45601. Tel: (740) 779-9512. Fax: (740) 779-9514. Here is a selection of good needlepoint stores who sell my kits:

A Stitch in Time, Bethel, CT 06081
Busy Hands, Ann Arbor, MI 48104
Carrell Bolton's Needlepoint, La Jolla, CA
Chaparral Needlework, Houston, TX 77027
Churchmouse Yarn, Bainbridge Island, WA 98110
Golden Thread Needlearts, Rochester, NY 14444
Grace Robinson & Co, Freeport, ME 04032
Needlepointer, Everett, WA 98201
Needlepoint.Com, Raleigh, NC 27607
Pet Butler, Pensacola, FL 32504
Scarlet Thread, Vienna, VA 22180
Stitching Bee, Chatham, NJ 07928
The Needle Nook, Ligonier, PA 15658
The Needlepoint Joint, Ogden, UT 84401
Willow's End, Boothbay Harbor, ME 04538

Canada
Brickpoint, Montreal, PQ
Button & Needlework Boutique, Victoria, BC
Cross Stitch Cupboard, Ottawa, ON
Dick and Jane, Bowen Island, BC
Gwin Gryffon, Kingston, ON
Pointers, Toronto, ON
Urban Yarns, Vancouver, BC

INDEX

ACKNOWLEDGMENTS

Throughout my needlepoint years, my energy and enthusiasm have been sustained and encouraged by many people. I should like to thank them here.

Top of the list, naturally, are my husband Peter and my two sons Nick and Paul, who have all helped (and hindered!) in the way that only families can. Phyllis and Robert Steed have been conscientious and creative contributors for several years; I owe a lot to them. Jean Cook, Angela Kahan and Selina Winter, all colleagues from my days at the Royal School of Needlework, have perfected my sketchy ideas into exquisite examples of needlework. Peter Armatage and all my friends at Appleton deserve special praise for their patience and a style and standard of service that, unhappily, has long disappeared from many industries. Linda Parry at the Victoria and Albert Museum has proved an invaluable inspiration; Ron Worrall and Barrie Smith have always been encouraging and helpful, especially with the loan of their furniture.

The beautiful photographs in this book – thank you, John Greenwood – were shot in some superb locations. My gratitude, therefore, to Mrs Jean Wells and Dr Richard Dufty, CBE at Kelmscott Manor, Mrs Jane Grundy at Standen and the late Mr and Mrs Edward Hollamby at Red House for allowing John Greenwood and I to disrupt their lives with cameras and lights.

Thank you, also, to Maggie Pearlstine whose belief in my ability and determination to complete this project have moved mountains.

And, 'without whom none of this would have been possible', my most grateful and sincere acknowledgement is dedicated to the memory of William Morris himself. His influence will last for ever!